NICHOLAS ✠
✠ ALEXANDRA

NICHOLAS ✚
✚ ALEXANDRA

LUND HUMPHRIES

IN ASSOCIATION WITH THE

HERMITAGE AMSTERDAM

The exhibition was made possible by:

FOUNDER: **Sponsor** LOTERIJ

MAIN SPONSOR: FORTIS BANK

SPONSORS: KPMG FUGRO

INSURANCE: AON

SUBSIDISING BODIES:
Province of North Holland
City of Amsterdam

WITH THANKS TO THE:
W.E. Jansen Fund

PARTNERS:
Internet / IBM Nederland
Media partner / Avro Kunsttribune
Hotel partner / NH Hoteles
Travel partner / Voyage & Culture, Amsterdam
Courses / Vrije Academie voor
Kunsthistorisch Onderwijs, Amsterdam

HERMITAGE AMSTERDAM

CONTENTS

HERMITAGE ⚜ AMSTERDAM

FOREWORD

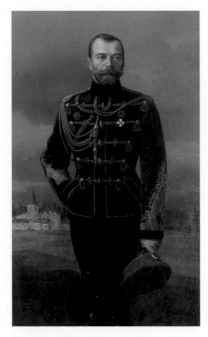

PORTRAIT OF TSAR NICHOLAS II, *1915–1916*
Unknown Artist
(second half 19th/early 20th century)
oil on canvas
Nicholas II (1863–1918) was the oldest son of
Tsar Alexander III and Tsarina Maria Fyodorovna.
In 1894 he succeeded his deceased father as tsar./A.P.

CAT.NR. 22

In Amsterdam there is a new museum that is Russian in origin. Its birth was exuberantly celebrated on 24 February 2004. The newcomer has flourished. Seven months have passed and with it the 100,000 visitors mark. And this is only the beginning, the first step towards a major museum in 2007.

That the Amsterdam Hermitage already attracts such an amazing interest is definitely due to people's curiosity about this new asset. Another reason for the impressive attendance is of course the superb site and the theme of the opening exhibition, Greek Gold. Just as relevant is the growing interest in the cultural heritage and history of Russia. It is the fruit of the attention paid to it in the Netherlands in recent years. Now we have our own Hermitage establishment in Amsterdam, this interest can only grow. The museum on the Amstel will put on exhibitions of special collections that cannot be seen anywhere else in Holland. The Hermitage in St Petersburg will be an inexhaustible source.

Visitors to the museum will also be introduced to the history of Russia. This catalogue is published to coincide with the first exhibition on the subject. Its theme is the intensely human tale of Nicholas and Alexandra, that is so profoundly intertwined with the history of their country. The political upheavals that awaited them and which eventually led to the Revolution of 1917 signalled the last hour of three centuries of Romanovs as well as the dramatic end of the couple themselves. Literally. In 1918 they were murdered with their five children. The exhibition shows

the closing phase of the dynasty in a political context and in that of the life of Nicholas and Alexandra.

The happy moments in Nicholas's life, his childhood surrounded by love, his marriage with Alexandra and the birth of their five children soon made way for traumatic experiences. His grandfather's assassination and the death of his father meant that he had to accept high office at the age of twenty-eight. The haemophilia of his only son and intended heir Alexei, the death of many Russians on the battlefield and the inevitable political reforms that forced him to concede absolute power in favour of a constitutional monarchy, the First World War – all these factors prevented the family from simply enjoying the life at court, despite their glamour and wealth. In 1917 Nicholas abdicated. The new government sent the tsar and his family to Siberia. There they were viewed as a permanent threat to the new Russia and a year later they were murdered by the Bolsheviks, who had meanwhile seized power.

Contemporary Russia views this history with different eyes: the remains of the family that were recovered after 1990 were laid to rest in 1998 alongside the other tsars in the Peter and Paul fortress in St Petersburg.

This epoch full of drama contains all the elements for a fascinating exhibition. It begins with the coronation, with the magnificent costumes and regalia designed by Fabergé; the family life of Nicholas and Alexandra is then illustrated on the basis of many personal objects; the role of the Church and State and of the tsar in relation to them can be seen in icons and religious objects, in photographs and other pieces.

Three hundred years ago St Petersburg was founded at the mouth of the Neva as a 'window on Europe'; for us the Amsterdam Hermitage is a doorway giving access to the rich history of Russia and to a wealth of art treasures.

An open door.

Ernst W. Veen

DIRECTOR OF THE HERMITAGE AMSTERDAM

THE SPLENDOUR OF A DOOMED EMPIRE

'Mr. Emperor Nicholas Alexandrovich and Madam Empress Alexandra Fyodorovna' – that is the quaint form that was once used to address them; a best-selling biography of the pair however had as its title 'Nicholas and Alexandra'. A picture has been created of the couple as eternal lovers whose dearest wish was to enjoy a happy family life, but who were prevented in this by their responsibilities as tsar and tsarina. And this is a true picture. The history of this ill-starred couple who dreamed of domestic intimacy and who thought they could also bestow it on their subjects has almost become a historical cliché. Their tragic lives put in the shade the careers of many other monarchs who tried to combine royal responsibility and personal happiness.

Nicholas II and Alexandra Fyodorovna aimed to have both a public existence as tsar and tsarina and a private life. They thought it possible to combine the two, but their tragic fate proved that this could not be done. Divisions in Russia confronted the couple with a whole range of conflicting demands for which there was no adequate solution. The Russian people gave them some respectful nicknames and many others that were scornful and insulting.

Russia lost wars abroad, and it also lost domestic battles with radical socialism, sectarian mysticism and with the proponents of parliamentary democracy. An abscess grew in society – that of the revolution that created a fissure in the Russian empire, bringing about its fall. The tragedy of the nation was also that of the tsar and his family, who in many people's opinion had had a duty to act and therefore bore responsibility for all the disasters.

The period just prior to the revolution was also a time of remarkable cultural achievements in Russia. It has become known as the Silver Age of literature, with poets such as Alexander Blok, Nikolai Gumiliov and Anna Akhmatova. The Russian avant-garde in art and music has exerted a huge influence on western culture throughout the twentieth century. This flowering of the arts also provided a foundation for the *Ballets Russes,* that had such an extraordinary impact on innovatory dance in Russia and internationally. The Russian court was celebrated for its extravagant and festive atmosphere. No-one doubted the truth of the phrase, 'splendid St Petersburg'.

In this situation of historical upheaval, a family appeared on the scene that typically set so much store by domesticity. We can regard it as a fluke of history or perhaps

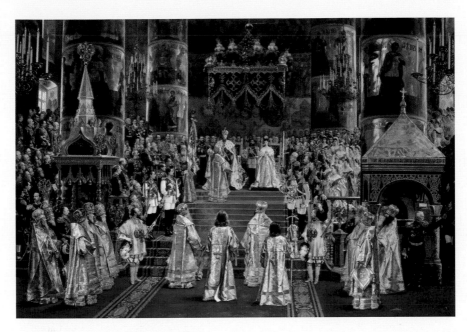

THE CORONATION OF TSAR ALEXANDER III
AND TSARINA MARIA FYODOROVNA, *1888*
Georges Becker (1845–1909)
oil on canvas

CAT. NR. 01

precisely as a wise lesson in that discipline. Because opposed to that chaos stood the most important pillar of society – family life.

The history of the tsar and his family during the tumultuous events in Russia has been overshadowed a little by a special emphasis on the memory of Tsarevich Alexei – a sickly but nonetheless charming youth, who was the symbol of both the hope and the agony of Russia. With his parents, he died a martyr's death; it was at once a political, religious and a family tragedy.

It is the history of Russia, that never forgets the tragic pages of its past but is always compelled to learn from them over again. There is of course much one could say about this. But the original objects, that are full of beauty and radiance due to the memories they evoke, tell the final episodes of the history of the tsars in a far more eloquent and reliable manner. All that is needed is an effort of the imagination.

Professor Mikhail Piotrovsky

DIRECTOR, STATE HERMITAGE MUSEUM, SAINT PETERSBURG

PRESIDENT, STICHTING HERMITAGE AAN DE AMSTEL

Queen Victoria
of Great Britain
and Ireland
1819-1901

⚭

Albert
of Alexander
Saxony-
Coburg-Gotha
1819-1861

Maria
Alexandrovna
(Marie of Hesse)
1824-1880

⚭

Alexander
Nikolaievi
1818-1881

♛

(1855-1881)

Alice
1843-1878

⚭

Louis
of Hesse
1837-1892

Maria Fyodorovna
(Dagmar
of Denmark)
1847-1928

⚭

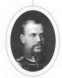

Alexander III
Alexandrovich
1845-1896

♛

(1881-1896)

Alexandra (*Alix*)
Fyodorovna
(Alice of Hesse)
1872-1918

⚭

Nicholas II
Alexandrovich
1868-1918

♛

(1896-1917)

Georgy
Alexandrov
1871-1899

Olga
Nikolaievna
1895-1918

Tatiana
Nikolaievna
1897-1918

Maria
Nikolaievna
1899-1918

Anastasia
Nikolaievna
1901-1918

Alexei
Nikolaievi
Tsarevich
1904-1918

✠ FAMILY TREE TSAR NICHOLAS II

Vladimir Alexandrovich 1847-1909 ⚭ Maria Pavlovna 1854-1920

Aleksei Alexandrovich 1850-1908

Pavel Alexandrovich 1860-1919 ⚭ Alexandra 1870-1891

Sergei Alexandrovich 1857-1905 ⚭ Elizabeth of Hesse (Elizaveta Fyodorovna) 1864-1918

Xenia Alexandrovna 1875-1969 ⚭ Alexander Mikhailovich 1866-1933

Mikhail Alexandrovich 1878-1918

Olga Alexandrovna 1882-1960

Irina Alexandrovna 1895-1970 ⚭ Felix Yusupov 1887-1967

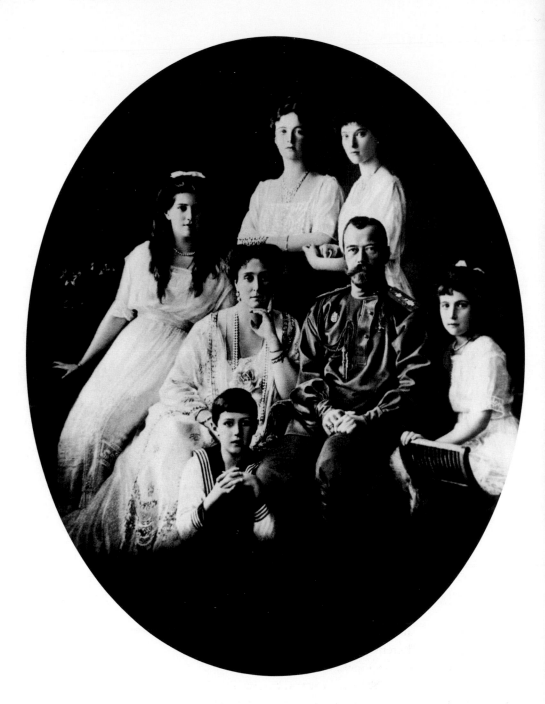

Biography tsar Nicholas II

New dating (present day)

1868	6 May	Birth of Nicholas II
1894	1 Nov.	Nicholas II becomes Tsar after death of Alexander III
	26 Nov.	Nicholas II marries Alix (Alexandra) of Hessen
1895	15 Nov.	Birth of daughter Olga
1896	14 May	Coronation in Assumption Cathedral, Moscow
1897	10 June	Birth of daughter Tatiana
1899	27 June	Birth of daughter Maria
1901	22 Jan.	Queen Victoria dies
	18 June	Birth of daughter Anastasia
1903	Nov.	During the congress of the Russian Social Democratic Party in London, party splits into two: the Mensheviks, led by Plechanov, and the Bolsheviks, led by Lenin and Trotsky
1904	4 Feb.	Japan declares war on Russia
	28 July	Minister of Internal Affairs, Pleve, is murdered
	22 Aug.	Birth of tsarevich Alexei
1905	1 Jan.	Bloody Sunday in St Petersburg
	17 Feb.	Grand Duke Sergei murdered
		February riots
	19 Aug.	Nicholas II allows formation of Duma, with limited power
	26 Oct.	Workers of St Petersburg form the first soviet
	30 Oct.	Nicholas II signs the October Manifest, in which he makes concessions to the Duma which has been proclaimed; it will have full legislative power and more people will be given the right to vote
1906	22 Nov.	Anna Vyrubova and Rasputin pay their respects in Tsarskoye Selo
1914	28 June	Archduke Franz Ferdinand of Austria murdered in Sarajevo
	1 Aug.	Germany mobilizes and declares war on Russia
	1 Sept.	St Petersburg is renamed Petrograd
	4 Sept.	Pact between France, Russia and Great Britain
1916	30 Dec.	Rasputin murdered
1917	16 March	Tsar Nicholas II abdicates; the imperial family is put under house arrest in Tsarskoye Selo
	31 July	Imperial family taken to Tobolsk in Siberia
	15 Sep.	Kerensky proclaims the republic of Russia
	7 Nov.	October revolution
	5 Dec.	Truce between Germany and Russia
1918	14 Feb.	Russia introduces the Gregorian calendar
	26 Apr.	Nicholas, Alix and Maria are taken to Yekaterinburg. The rest of the family arrives there on 22 May
	17 July	The ex-Tsar and his family are executed on the orders of Lenin
1998	17 July	Nicholas II and Alexandra and three of their children are reinterred in the Peter and Paul Cathedral in St Petersburg.

St Petersburg:
The palaces of the Romanov-family

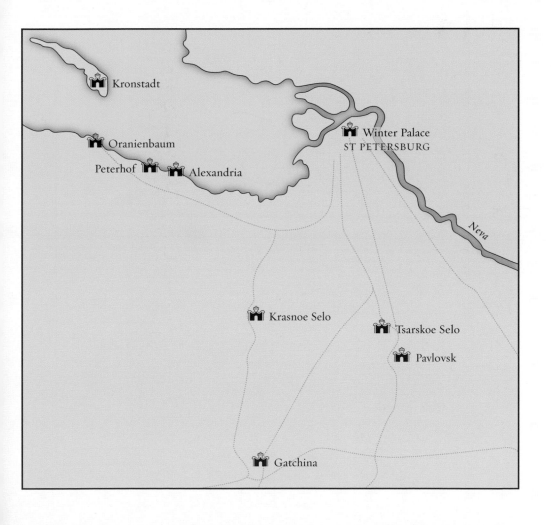

✠

'We may measure the strength of the Russian Empire

by the battering it had endured,

by the disasters it had survived,

by the inexhaustible forces it had developed,

and by the recovery it had made.'

Winston Churchill
The world crisis, 1916–1918, vol i, New York 1927

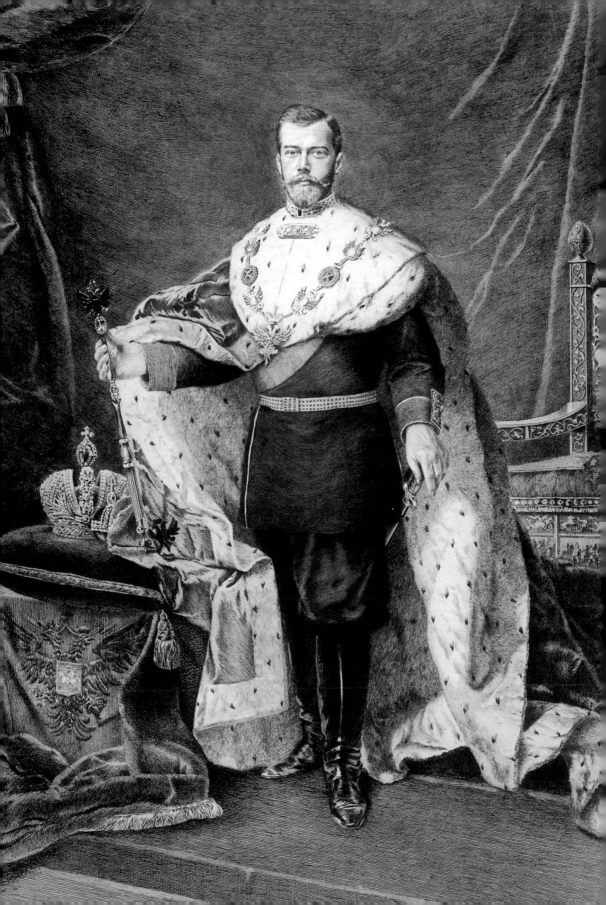

Nina Tarasova

Russia

in the reign
of Nicholas II

Coronation Portrait of
Tsar Nicholas II, 1896
Fernand Desmoulin
(1853–1914)
etching

CAT. NR. 45

PORTRAIT OF KONSTANTIN POBEDONOSTSEV, *1902*
Karl Karlovich Kubesch
(late 19th/early 20th century)
albumin print

CAT. NR. 86

PORTRAIT OF SERGEI WITTE, *c. 1915*
Yosif Adolfovich Otsup
(late 19th/early 20th century)
silver bromide print

CAT. NR. 94

In 1894 a new monarch of the Romanov dynasty ascended the throne. As yet there was no sign that their rule would soon come to an end. Only a few farsighted figures had any idea that Nicholas II would be the last tsar of Russia.

From his father Tsar Alexander III, Nicholas inherited a country with a thriving economy and a social and political situation that had stabilized; Russia was an empire that all the major powers had to take into account. Its material welfare was the product of the consistent and uncompromising policies pursued by Alexander III, who revoked the liberal reforms of the 1860s and 1870s and provisionally put a stop to the outbursts of revolutionary terrorism.

On the day his father died Nicholas II spoke with a sob in his voice, 'I am not ready to be a tsar. I am not capable of governing an empire.' He had no definite programme nor did he have the character to take decisions independently; he ascended the throne with a single resolve – that of following in his father's footsteps. In January 1895, on receiving the representatives of the provincial nobility, Nicholas made a statement warning them against any 'foolish daydreams about participating in domestic affairs of state' and emphasized that he 'would maintain the principle of autocracy as vigorously and uncompromisingly' as his predecessor.

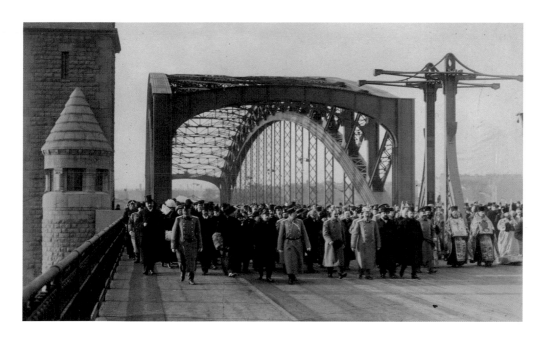

OPENING OF THE PETER THE GREAT BRIDGE
(BOLSHEOKHTINSKY BRIDGE) OVER THE NEVA, *1911*
Karl Karlovich Bulla (*1853–1929*)
photo

CAT. NR. 63

He attempted to stay true to the political principles of Alexander III and his most important advisor Konstantin Pobedonostsev, yielding only reluctantly to the demands of the time. Pobedonostsev, an eminent jurist, professor of law, honorary member of a number of universities and of the Académie Française and director general of the Holy Synod of the Russian orthodox church, was an ardent opponent of every project for a constitution. He described the reforms of Alexander II as a 'criminal mistake'.

Besides Pobedonostsev, Nicholas II retained another of his father's advisors, the minister of Finance, Sergei Witte, a passionate advocate of Russian integration with Europe. His efforts to combine the course of Pobedonostsev and that of Witte led to serious inconsistencies in his policies, the repercussions of which however would only later make themselves felt.

SERGEI WITTE

Sergei Yulyevich Witte, a leading economist and statesman, occupied the post of minister of Finance from 1892 to 1903. A member of a Dutch family promoted to the Russian aristocracy in 1856, Witte began his brilliant career as director of the southwestern regional railways. As a high-flying specialist and gifted administrator and politician, he viewed industrialisation as an essential prerequisite for Russia to take its place among the leading Western countries.

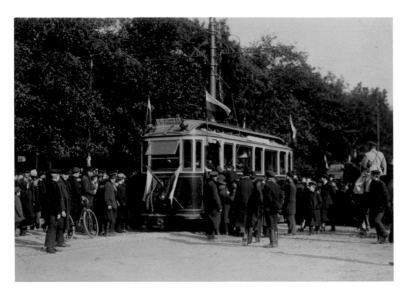

OPENING OF THE
FIRST TRAMRAIL IN
ST PETERSBURG, *1907*
Karl Karlovich Bulla
(1853–1929)
photo

CAT. NR. 60

Alexander III began by appointing Witte director of the department of Railway Affairs in the ministry of Finances (1889); he then chose him as his minister of Communications (1892) and Finance (1892). Under him the Ministry took vigorous measures to expand Russian industry. To increase the nation's productivity and accelerate the offloading of goods, railways were built on a vast scale. Russia worked full speed ahead to overcome its backward economic situation. The railways programme, embarked on under Alexander II, proceeded with remarkable rapidity. In 1891 work was started on the trans-Siberian railway, which was strategically important as well as having huge economic significance.

In a secret memorandum Witte, who was responsible for this hugely ambitious project, wrote that, 'From a political and strategic point of view the importance of this railway is that it gives Russia the shortest route for transporting its armed forces to Vladivostok and concentrating them in Manchuria, on the shores of the Yellow Sea and at a short distance from the capital of China. (...) This increases the prestige and influence of Russia, not only in China, but in the entire Far East.'

Ten years later the first trains travelled along the main line to Siberia. A journey from Moscow to Port Arthur took sixteen days. In around 1905 the total length of the railway network of the Russian empire was 62,000 km, giving Russian industry an infrastructure that enabled the country to gain a leading position internationally.

Heavy industry expanded, above all in the south and north-western regions of Russia. Gigantic metal-producing firms were founded, equipped with modern technologies. In the 1890s the speed of development of Russian industry easily surpassed that of other leading western nations, and by the end of the century the country led the rest of the world in industrial growth. In its general

economic level Russia vied with that of Japan in those years. Although its share in world production was not yet great (amounting to some 4% at the beginning of the twentieth century), it increased steadily (reaching 7% before the First World War).

One important indicator of Russia's industrial growth was the genuine improvement in its foreign trade balance, with the country beginning to acquire revenues from exports. At the end of the nineteenth century it had a balanced budget and gold reserves of over 500 million roubles. Exports of Russian grain increased continuously: at the start of the twentieth century they were three times greater than in the mid-nineteenth century.

Native industrialists were offered privileges, benefits and credits. Some branches of production received special protection from the state – for instance, that of sugar. Measures to increase treasury reserves and stabilize the rouble also proved effective. One of these was the introduction of a wine monopoly in 1895.

In 1896-1897 Witte realized a financial reform – one that his predecessors had worked on but had not succeeded in pushing through – the introduction of the gold standard; state letters of credit entered circulation along with gold. The exchange rate of the rouble, fixed at half an American dollar, stayed at that level till the outbreak of the First World War. The possibility of converting the rouble made the currency creditworthy in a real sense and facilitated an influx of foreign capital, especially French and Belgian. In 1899 the decision was taken to abolish all restrictions for investors in the industrial and financial sectors. At the turn of the century the total of western investments in Russian industry amounted to some 900 million roubles.

Like other European countries, industrial growth in Russia was accompanied by increased exploitation of the proletariat, who in turn protested about their working conditions. To reduce social tensions, factory legislation was passed in Alexander III's reign, that put some restrictions on the arbitrary conduct of factory owners, in striking contrast with most developed countries which did not yet have any legal restrictions on adult male labour. Russian companies introduced savings books, payment in kind was forbidden, as was the employment of children under twelve; night work was banned for women and children under seventeen in the textile industry; the working day for teenagers was limited to eight hours, and they were offered the possibility of three hours schooling every day. A factory inspectorate supervised the enforcement of the new legislation. And although strikes were forbidden, workers had the right to dissolve their contract with the owner of the company 'in the case of ill treatment'. These laws were followed by a whole series of measures to protect the economic rights of the employees.

As a far-sighted politician Witte urged that a solution be found for the nation's most fundamental problem, 'the question of the peasantry', pointing out that the only way of guaranteeing social stability was to guarantee them land. Unfortunately the government did not consider the time was ripe for his proposals, nor did it give its support to the assembly for the agrarian industry over which he presided from 1902 onwards. Another outstanding statesmen, Pyotr Stolypin, was put in charge of land reforms instead. Russia had however made impressive advances under Witte, and despite the economic crises

that Europe suffered in the mid-1880s and in the period from 1901 to 1903, the country was well on its way to overcoming economic backwardness.

RUSSIA AND FOREIGN POLICY

At the outset of Nicholas II's reign Russia was already playing a weighty and consistent part in international affairs. The cautious, rational foreign policy of Alexander III, that earned him the title of 'peace-maker' ensured that the country did not get drawn into any of the conflicts in western Europe at the time. Not only did he avoid awkward situations; he also exerted a positive influence on the whole situation in western Europe. At the start of the 1880s Russia still did not have any reliable allies, but a treaty with the French Republic in 1891-1892 put an end to the country's diplomatic isolation. This alliance between the two countries was a decisive factor in the international balance of power in the period that followed; The Russian empire proved a loyal ally for France and from then on Europe's fate was decided not only in London, Paris, Berlin and Vienna but also in St Petersburg.

The policy of peaceful coexistence was one that Nicholas II could also appreciate and it suited his inner convictions. Unfortunately the time however was not yet ripe for such idealism. In the summer of 1898 a memorandum was handed to the representatives of the foreign governments in Petersburg, explaining the position of the tsarist government with regard to the arms race. Russia proposed concrete measures for arms control, including a proposal for an international conference on war and peace. And even though the European states regarded Russia's initiative as somewhat unworldly, the first international conference of delegates from 27 countries was held in The Hague in the summer of 1899. Motions were adopted for the peaceful resolution of armed conflicts and for establishing a code for the conduct of war on land and at sea. The most important result of the conference was the founding of the International Court of Justice in The Hague, that sits there to this day, under the flag of the United Nations.

At the beginning of the twentieth century the chief issue in foreign policy in Russia was the Pacific Ocean region. The increasing power of Japan, which had embarked on a period of active industrial expansion and was pursuing a policy of aggrandisement at the expense of Korea and China, formed a threat to Russia's security in the Far East and also impacted on the interests of France and Germany.

In government circles in Russia there was no consensus about how to deal with the question of the Far East. The 'war party', headed by Admiral Yevgeni Alexeyev, President of the Council of Ministers Ivan Durnovo, the Foreign Minister Vyacheslav Pleve and the tsar's brother-in-law Grand Duke Alexander Mikhailovich, argued for a hard political line against Japan without any concessions or compromise. A 'small war' moreover was seen as a means of averting a social crisis. In favour of a peaceful resolution of international hostilities was minister of Finance, Witte and the ministers of Foreign Affairs, Mikhail Muravyov and Vladimir Lamsdorf.

Discussions between Tokyo, Petersburg, Berlin, Paris and London in 1902-1903 proved fruitless. Engaged in modernizing its navy, Japan was preparing for an armed conflict. In the night of 27 January 1904 its ships

attacked a Russian squadron in the Korean port of Chemulpo and on 28 January the country declared war on Russia. This inglorious conflict, that lasted a year and a half, exposed the entire social and economic vulnerability of Russia and led to destabilization at home. Its futility became clear at the end of 1904, especially after the fall of the Russian stronghold of Port Arthur. Nonetheless the Second Pacific Fleet was dispatched to the Japanese coast; in May 1905 it was overwhelmed by the Japanese navy in the Straits of Tsushima. The mood in Russia at the time can be described as one of shock, dejection and anger.

After discussions round the negotiation table in the American city of Portsmouth, Russia made peace with Japan. Due to the efforts of Witte, who headed the Russian delegation, the treaty was more an agreement between equal partners than a document testifying to a senseless war. The only important territory lost was the southern part of the island of Sakhalin, which was ceded to Japan. A successful peace however was not enough to eliminate domestic social discontent.

MEETING THE PRESIDENT
OF THE FRENCH REPUBLIC
FÉLIX FAURE
AT THE ENGLISH QUAY
IN ST PETERSBURG, 1898
Unknown Photographer
(19th century)
albumin print

CAT. NR. 93

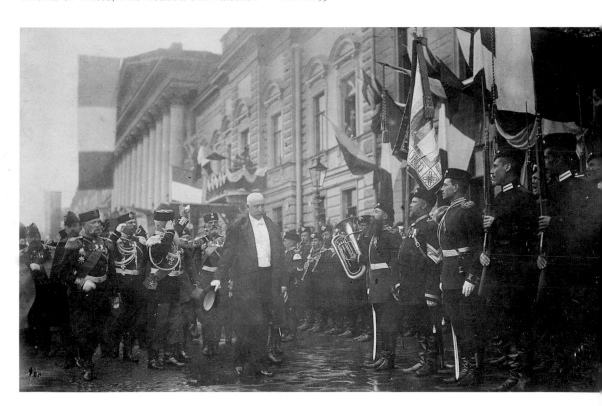

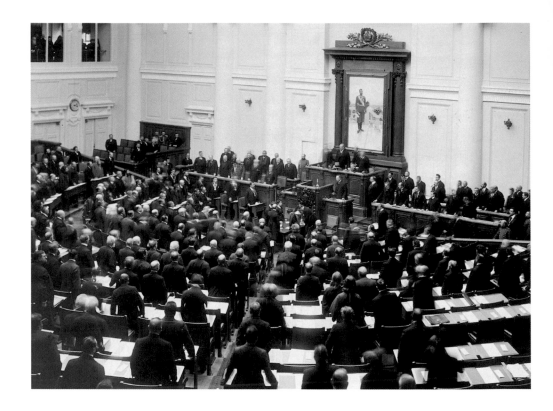

MEETING OF THE
STATE DUMA, *1900–1910*
Karl Karlovich Bulla *(1853–1929)*
silver bromide print

CAT. NR. 58

REVOLUTION

The Russian empire was in the throes of a revolution. It was the events of 'Bloody Sunday', 9 January 1905, that is usually thought of as having sparked it off, when thousands of workers of St Petersburg marched to the Winter Palace with a petition to the tsar stating their political and financial demands. The protest was seen as threatening the foundations of the state. In the absence of Nicholas II the authorities ordered the garrison troops that had arrived at the capital only days before to fire on the unarmed masses. 'It was a terrible day! Serious disturbances took place in St Petersburg. At a number of points in the city the garrison troops were forced to fire, with many dead and wounded. O Lord, how painful and distressing it is!', the tsar, wrote in his diary for 9 January, from Tsarskoe Selo. The unrest among workers, peasants and students spread to many parts of the country in the winter and spring of 1905. On 4 February a member of the Revolutionary Socialist party, Ivan Kalyaev, assassinated the governor of Moscow, Grand Duke Sergei Alexandrovich. In the army too an extraordinary development occurred in the summer of 1905 – the mutiny of the crew of one of the finest ships of the Black Sea fleet, the battleship Prince

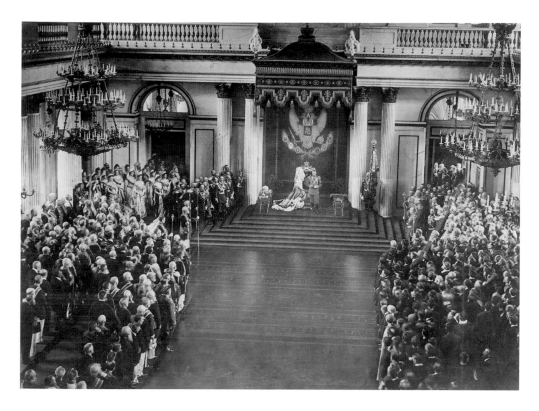

CORONATION SPEECH BY
TSAR NICHOLAS II, *1906*
K.F. Hann & Co, Photo Studio
silver bromide print

CAT. NR. 64

Potemkin Tavrichesky. The defenders of the
autocracy, the army and the fleet were on
the brink of collapse.

Without any suspicion of the disasters
that would presently strike both Russia and
himself, and under pressure from the liberal
sector of society, Nicholas II signed a mani-
festo on 17 October 1905, granting a con-
stitution. It promised the people basic civil
rights and liberties, ranging from the free-
dom of conscience, speech and assembly
to the setting up of an elected legislative

body, the State Duma. The manifesto of
17 October was an extremely important first
step towards a constitutional state in Russia.

And yet the 'Russian uprising, senseless
and without quarter' continued. The first
Russian revolution reached its climax in
November/December 1905, when it spread
to Poland, the Baltic States, the Caucasus and
Siberia. A group was then formed in the gov-
ernment with the special task of putting an
end to public demonstrations. It was led
by the Home Secretary Pyotr Durnovo, an
appointee of Prime Minister Witte.

Elections to the first State Duma were
held in February and March 1906 under
conditions that were hopelessly unstable.
The opposition parties won with 55% of the
vote. On 27 April 1906, a day before the
opening session, the deputies were received

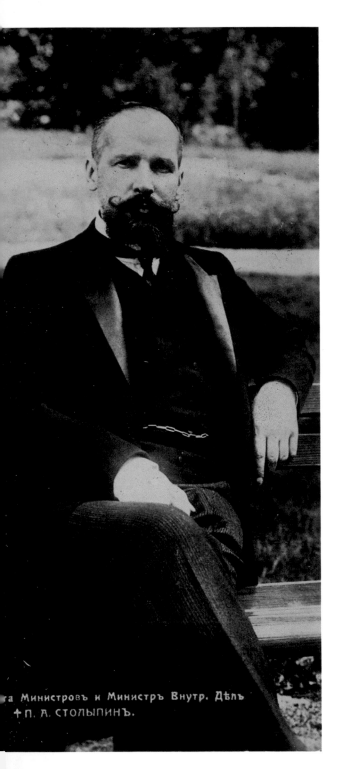

а Министровъ и Министръ Внутр. Дѣлъ
† П. А. СТОЛЫПИНЪ.

PORTRAIT OF
PYOTR STOLYPIN, *1900–1910*
Unknown Photographer
(late 19th/early 20th century)
photo

CAT. NR. 90

by Tsar Nicholas II in Saint George's Hall in the Winter Palace.

Lieutenant-general Mosolov, head of the secretariat at the Ministry of the Imperial Court wrote: 'The procession started from the private apartments and headed towards the Throne Room. The tsar was preceded by the highest officers of the state, bearing the imperial regalia: the flag and the seal (on red cushions), the sceptre, the mace and the crown, studded with diamonds. They were accompanied by grenadiers with tall bearskin helmets, in full uniform. The deputies were allocated seats in the Throne Room to the right of the exit; in front of them stood the senators. On the left were the members of the Council of State, the highest ranks of the court and ministers.

'His majesty and the two tsarinas [the tsar's mother and wife] came to a halt with the other members of the imperial family in the middle of the hall. The regalia were brought to two platforms on either side of the throne, that was half covered with a wide imperial robe, draped over red tabourets. A lectern was bought in and his majesty was anointed by the metropolitan bishop. Prayers were then said, after which the tsarinas and the leading dignitaries walked to a platform left of the throne. The tsar waited alone in the middle of the hall, until the tsarinas had arrived at their places, after which he walked with measured tread to the throne and sat

down. He was then handed the address from the throne which he read sitting upright with a loud clear voice.' In his speech greeting 'the best people whom he had instructed his subjects to choose out of their midst', Nicholas II expressed the hope that 'love for the Fatherland, the passionate desire to serve it' would 'inspire and unite' the deputies'.

The imperial Court was meanwhile shocked by the calculated scorn of the deputies for the tsar's speech. 'The overwhelming majority of those who were sitting demonstratively in front consisted of members of the Duma dressed in work shirts and shirtsleeves. One tall figure in the front row was particularly striking as he stared at the throne and all around him with a mocking and impudent look on his face', the Finance Minister Vladimir Kokovtsov tells us.

The Duma began proceedings in the Tauride palace with an immediate display of hostility towards the tsarist state; in July 1906 Nicholas issued a *ukase* dissolving the body and ordering new elections. With the Duma, part of the Russian cabinet was also dismissed. Pyotr Arkadyevich Stolypin (1862-1911) was appointed as the new President of the Council of State; he also kept the post of minister of Home Affairs for himself. Stolypin was an enlightened and purposeful politician, a man of resolute courage and an ardent patriot; he was the 'custodian of the new cabinet'. As a convinced monarchist, he considered that Russia and absolute rule were synonymous; to reinforce the constitution, however, it was essential to organize a basis of support within the people, a class of strong landowners and entrepreneurs. To achieve this he pressed for a speedy resolution of 'the land question', that would give the peasants genuine free-

dom and the power to dispose of their land. In Stolypin's view serious reforms such as this required lengthy and complicated preparations; they had to be implemented methodically and consistently, so no loopholes were left.

Simultaneously with the reforms, he therefore proceeded to combat the revolution and terror that had overwhelmed the nation. The terror even affected the prime minister himself: in August 1906 a massive explosion on his dacha injured about 60 people, including his daughter and son. In his memoirs Kokovtsov wrote, 'We were all impressed by Stolypin's calm and self-control. He at once acquired great moral authority and it became clear to everyone that an indubitably noble heart was beating in his breast; with a willingness to sacrifice himself if need be for the general good and a resolute will to achieve what he deemed essential and useful for the state. In short, Stolypin emerged from this situation forthwith as a leader whom everyone acknowledged.'

The success of the reforms depended to a large extent on the elections for the second State Duma at the beginning of 1907. Once again however the results were unfavourable for the government, with the leftist parties emerging from the ballot even stronger. Stolypin's programme provoked ferocious criticism. It was then that the Prime Minister pronounced his prophetic words about the

BICENTENARY MEETING
OF THE SENATE, *1909*
K.F. Hann & Co,
Photo Studio
silver bromide print

CAT. NR. 65 (next page)

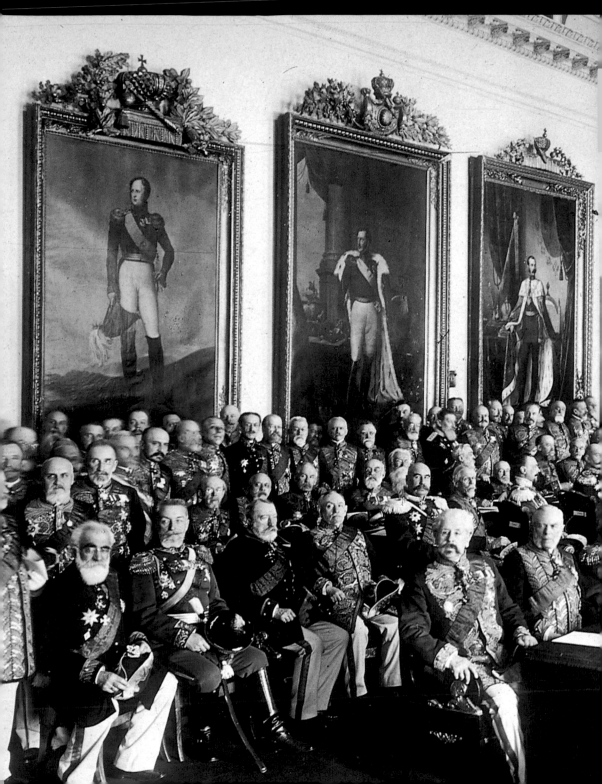

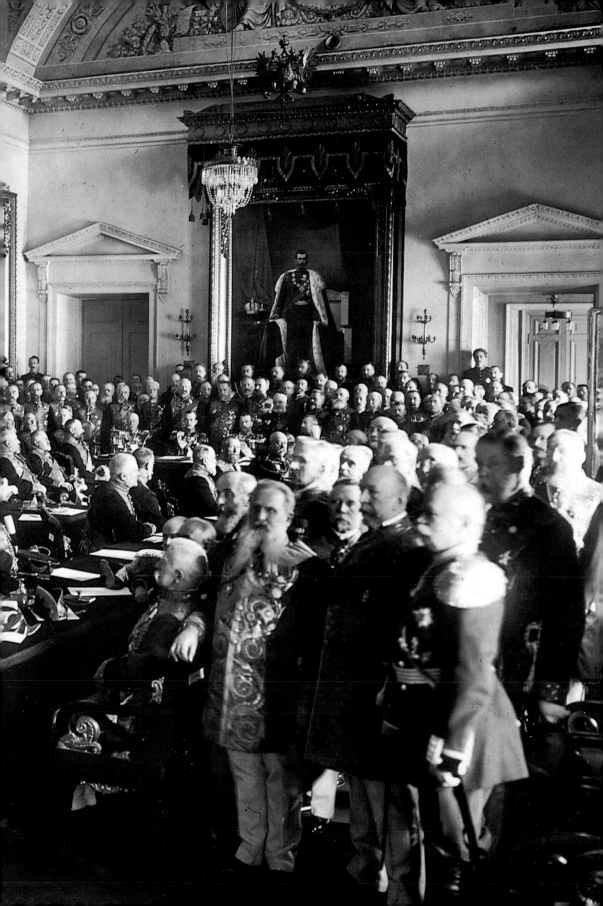

influence prevailed in the highest court circles: this was Grigori Rasputin. Stolypin's standing with the court declined. At the end of August 1911 he was assassinated in the Kiev theatre by the terrorist Dmitry Bogrov.

The reforms carried out by Stolypin's cabinet and later by his like-minded successors, Kokovtsov and Alexander Krivoshein aimed for the long perspective rather than immediate results. Nonetheless the last years before the First World War saw genuine economic growth in various areas of society.

Russian industry was in the throes of an international monetary crisis in 1900, a situation that was exacerbated by political instability, and it only slowly managed to recover from the depression. By 1910 however the economic tide had visibly begun to turn. In comparison with 1900, figures in, for instance, coal and cast-iron production, the iron and steel industries, cotton-processing and sugar production had doubled. In the countryside the wheat harvest increased and grain exports also grew significantly. All of this was the direct result of government policies. On the eve of the war Russia enjoyed a higher economic growth rate than Germany, Great Britain, France and the United States. National revenues also grew by an annual figure of 6 percent from 1909 to 1913, which would have meant a doubling over a twelve year period. Russia had a strong budgetary

left deputies, 'What you want is great disturbances, but we want a great Russia.' The second Duma survived less than six months and was dissolved by *ukase* on 3 June 1907.

The third Duma survived the full term of five years; its extremely conservative composition gave Stolypin the opportunity to implement his essential agrarian legislation; he also pushed through important measures towards improving the education of the people and the reform of the army and local and regional government. But the weaker the revolutionary movement became and the more a mood of social reconciliation took hold of the country, rightist groups – that had plenty of support at court – replaced those on the left in attacking Stolypin. The Prime Minister also acquired a strange but very powerful opponent, who exploited the tsarina's superstitious character and whose

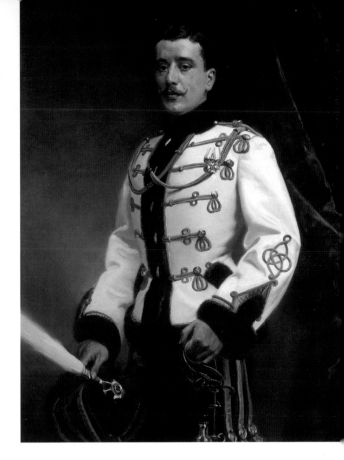

policy, that was not upset even by the war with Japan or the Revolution of 1905. In 1913 revenues exceeded expenditures by almost 400 million roubles.

ART AND CULTURE

Even more impressive was the flowering of intellectual life in Russia during Nicholas II's short reign. In all areas of biology, mathematics and physics Russian scholars made discoveries with international implications. Russian philosophy experienced a Renaissance. And the brilliant flight of literature, music, theatre and the visual arts astounded the rest of Europe, revealing as it did a new, unknown Russia. The chemists Dmitry Mendeleev and Sergei Lebedev, the physicists Alexandr Popov and Konstantin Tsiolkovsky, the biologists Ivan Sechenov and Ivan Pavlov, the historians Vasily Klyuchevsky and Sergei Platonov, the philosophers Nikolai Berdyaev and Sergei Bulgakov, the writers Leo Tolstoi and Anton Chekhov, Alexandr Blok and Anna Akhmatova, the artists Ilya Repin and Valentin Serov, the composers Alexandr Skryabin and Sergei Rachmaninov, the theatre directors Konstantin Stanislavsky and Vsevolod Meyerhold, the great performers Fyodor Shalyapin, Vaslav Nijinsky and Anna Pavlova and patrons and collectors such as Sergei Diaghilev, Ivan Morozov and Sergei Shchukin. One could go on, but this list gives one some idea of the contribution of Russian culture, during its 'silver age' at the end of the nineteenth century and the beginning of the twentieth. St Petersburg and Moscow rivalled Paris and Munich as international centres of art. Life in St Petersburg, the political, social, military and cultural capital of the Russian empire was indeed extraordinarily rich.

The presence of the tsar and his family, often invisible, left its mark on the city. Practically all the social institutions they ever visited have a plaque marking the occasion. No single relevant event in the life of St Petersburg escaped the notice of Nicholas II, whether it was the consecration of a church, the opening of a new bridge across the River Neva, the founding of an educational institute, the launching of a new ship, a premiere at one of the imperial theatres, the unveiling of a monument, the opening of an exhibition or a new museum or

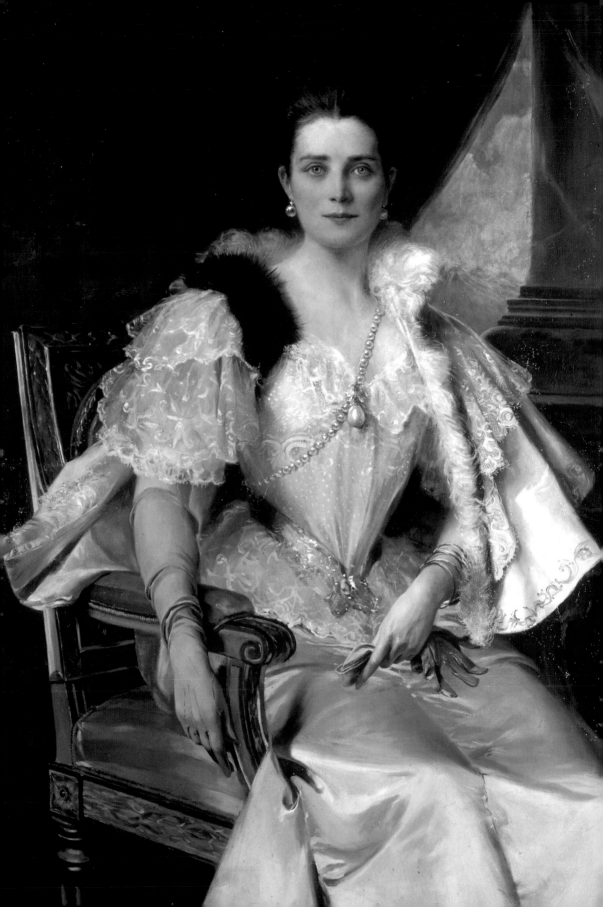

a ceremony presenting a regiment with its colours. 'The sound of ceremonial marches never ceased here. Here and there you heard the ritual of commanding officers saluting the tsar; and the lavishly decked-out coaches of the palace would ride past the defenders of the nation on the front line.'

LIFE AT COURT

Meanwhile the heart of St Petersburg, the majestic Winter Palace remained increasingly empty, becoming ever more purely symbolic of the Romanovs. After the birth of his successor Nicholas II and his family lived in the Alexander Palace in Tsarskoe Selo. The imperial family, whose daily life increasingly recalled that of the European bourgeoisie, was waited on by a whole range of court personnel; there were countless different ranks, quite apart from the army of valets, footmen and other lackeys. All the financial and other everyday problems of the tsar's family were successfully dealt with by the Ministry of the Court under Baron Vladimir Fredericks.

The 'great' (imperial) court and the 'small' courts (of the Grand Dukes) operated in different ways. The family of Nicholas II had little contact with the aristocracy of St Petersburg, the brilliant world of high society. And although the small courts lived an increasingly open public life, the Romanovs largely lived isolated from the outside world.

PORTRAIT OF DUCHESS
ZINAIDA YUSUPOVA, *1894*
François Flameng *(1856–1923)*
oil on canvas

CAT. NR. 17

It was only during exceptional events with a relevance for the throne that the imperial family and its entourage – the highest nobility – appeared in public together.

The beginning of the twentieth century was rich in major national feast days. It was as though, in expectation of its end, Russia was once more 'leafing through' the most important pages of its greatest historical period: the second centenary of the founding of St Petersburg (1903); the jubilee of the highest state institutions, the Senate (second centenary, 1911) and the Council of State (first centenary, 1910); the second centenary celebrations of the battle of Poltava (1909) and the first centenary of the victory over the France of Napoleon (1912); as well as other jubilee years for the founding of many units of the Russian army and navy.

The last great national occasion, the third centenary of the founding of the Romanov dynasty in 1913, was also the last year of peace for Russia as a monarchy. In 1613 the Assembly of the Land had unanimously appointed the youthful Mikhail Fyodorovich Romanov as tsar. Three centuries later the jubilee of this great national event was celebrated far and wide with great solemnity. This feast day highlighted the historical continuity of the state, the power of the tsars and the spirit of the nation. The jubilee celebrations began in February in St Petersburg, after which, in May, the imperial family toured the provincial governments of Central Russia, and the cities of Vladimir, Suzdal, Nizhny Novgorod, Yaroslav and Rostov Veliky. On 19 May 1913 the distinguished visitors arrived in Kostroma; it was there, in the monastery of Ipatiev, that Mikhail Romanov had been crowned tsar. The jubilee was also celebrated in Moscow, with splendid receptions, banquets

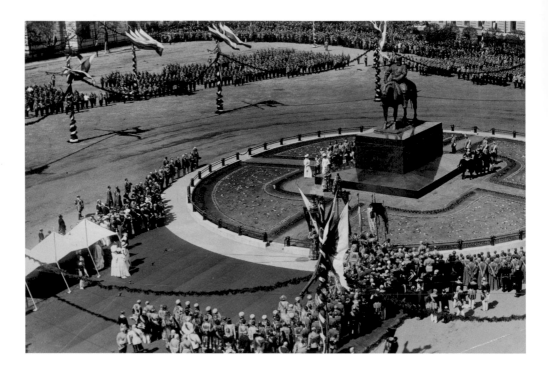

UNVEILING OF THE MONUMENT
TO TSAR ALEXANDER III
ON ZNAMENSKAYA SQUARE IN
ST PETERSBURG, *1909*
Karl Karlovich Bulla (*1853–1929*)
photo

CAT. NR. 61

and parades. There were also some concerts and public spectacles that had the sole aim of extolling the institution of the monarchy.

THE BEGINNING OF THE END

The jubilee celebrations were unable to stem the tide of events however. Behind the façade of ambitious official measures, a deep-seated and increasingly visible, social unrest was gathering strength. None of the social, economic or diplomatic achievements were of any avail; on the contrary, the opponents of tsarist rule exaggerated as much as possible the mistakes and failures of the government. With the prospect of a bloody world war, the monarchy became psychologically isolated.

Meanwhile Europe was rushing headlong towards the most disastrous armed conflict in its history. The general political situation continued to be decided by the relations between the four powers – France, Germany, England and Russia. Faced with increasing aggression from Germany, Paris and London found common grounds on many issues; and in 1907 an unprecedented treaty was signed between Russia and Great Britain. This led in turn to a geopolitical coalition, the Triple Entente, in opposition to the military pact between Germany and the Austro-Hungarian Empire. The treaty was further reinforced by the official visits to Russia of King Edward VII of England in 1908 and the French president Poincaré in 1914.

This system of opposing coalitions how-ever did not guarantee a balance of power in Europe; on the contrary, it destabilized an already delicate situation. The chief source of tensions on the continent was the Balkans. Due to Nicholas II's diplomatic efforts, Russia managed to avoid direct involvement in the Balkan wars of 1912 and 1913; he preferred to make concessions rather than jeopardize peace.

In 1914 however a further crisis in the Balkans led to world war. The tsar was deeply reluctant to become involved, being tem-peramentally an opponent of armed conflict. Moreover he knew that in materials and

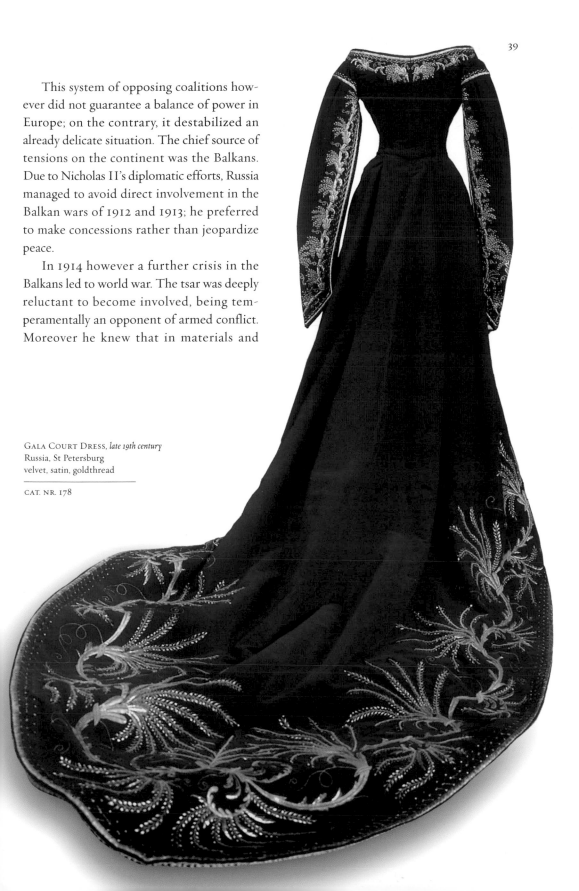

GALA COURT DRESS, *late 19th century*
Russia, St Petersburg
velvet, satin, goldthread

CAT. NR. 178

preparedness the Russian army, despite efforts at modernization, was no match for that of Germany. Above all, he was only too aware that military failure would lead to a revolutionary uprising, that would be even worse than that of 1905/1906. But he did not feel free to let down his fellow Slavs in Serbia. Nicholas had made up his mind.

The war changed the appearance of Russia and its people's manner of life, including that of the members of the imperial family. All their thoughts now were concentrated on achieving victory, and they thus trimmed their existence, renouncing many of their family usages.

In the first months of the war the country was filled with a surge of patriotic pride; the papers proclaimed the unity of the nation in the face of the German peril. In 1915 however, after the Russian army had suffered enormous casualties, with its most important regiments more or less disintegrating in bloody battles, it lost heart as well and patriotic sentiments made way for despair. At home discontent grew with a government that had shown itself incapable of bringing the war to an end or preserving national stability. Many people saw Grigori Rasputin who had attached himself to the Tsar's family as the main culprit for the disasters of war, but his murder in 1916, that was widely applauded, did not change the situation. The crisis was coming to a head.

At the beginning of 1917 the previously silent masses – workers, soldiers and peasants – were now beginning to stir in an outburst of anti-war sentiment. Their mood was skilfully exploited by the radical left parties for their own ends. On 27 February Nicholas II, who was stationed in the General Headquarters in Mogilyov [now in Belarus], received reports of serious disturbances in the capital. The situation had become critical and state power was paralysed. The next morning the Tsar left Mogilyov for Petrograd. The route of his train had to be altered, because many stations were in the hands of revolutionary troops.

By now the monarchy had ceased to exist in the capital in any real sense. True power lay with the provisional government, and the troops had already started swearing oaths of loyalty to it. Under the walls of the Tauride Palace, the seat of the Municipal Duma, an endless meeting was in progress. Some of the deputies of the Duma proposed a meeting with the Tsar to persuade him to abdicate. On 2 March 1917 in the saloon car of the Imperial train Nicholas II, the seventeenth monarch of the Romanov dynasty, signed a Manifesto in his own name and that of his successor Tsarevich Alexei Nikolaevich renouncing the throne in favour of his younger brother Mikhail, because he no longer felt able to bear the burden of imperial power.

'With a rattle, a crash and a screech an iron curtain has fallen on the History of Russia. The Play is over' (Vasily Rozanov, Russian philosopher, 1918).

PORTRAIT OF COUNT FELIX
SUMAROKOV-ELSTON, *c. 1908*
R. de San-Gallo
(late 19th/early 20th century)
watercolour, gouache on ivory

CAT. NR. 40

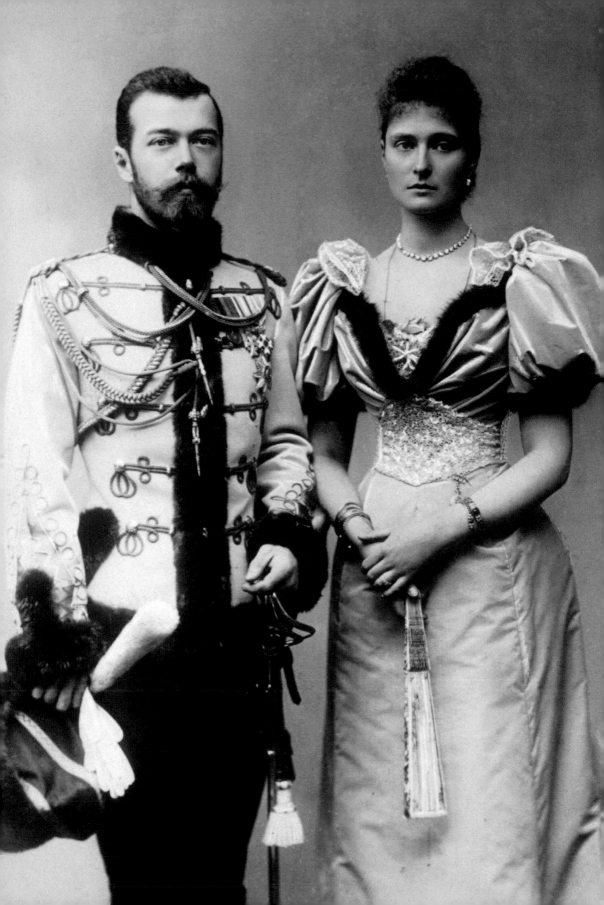

Galina Komelova

Nicholas and Alexandra

the last tsar and tsarina

PORTRAIT OF GRAND
DUKE ALEXANDER
ALEXANDROVICH AS HEIR TO THE THRONE,
1875–1885
Vasili Pavlovich Chudoyarov (*1831–1892*)
oil on canvas

CAT. NR. 18

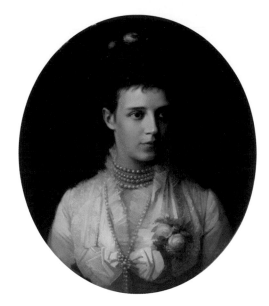

PORTRAIT OF GRAND DUCHESS
MARIA FYODOROVNA, *1870–1880*
Unknown Artist
(*second half 19th century*)
oil on canvas

CAT. NR. 20

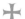

In 1917 the historian Sergei Melgunov wrote, 'The reign of Nicholas II has certainly been one of the bloodiest ever. Khodynka Field, two wars costing many lives, two revolutions, and various disturbances and pogroms in between, ending in merciless punitive expeditions under the slogans "take no prisoners" and "no quarter for bosses".' The reign began in 1894, after the unexpected death of tsar Alexander III at the age of forty-nine. His son Nicholas's accession and coronation was overshadowed by the frightful events on the Khodynka Field that became known as 'Bloody Saturday'. From then on Nicholas was nicknamed 'the Bloody'. The period ended with the tragedy in July 1918 in the Ipatiev house in Ekaterinenburg where, according to the majority of sources, the entire family of the last tsar was brutally murdered.

The more than tragic figure of Nicholas II was fatal for Russia. The authors of the many memoirs of the time portray him as highly educated and friendly in his dealings with people. 'I believe him to be the most charming person in Europe', one contemporary wrote, 'with an extremely modest private life, deeply religious, but utterly unsuited to the high office he inherited on the death of his father, tsar Alexander III.' From the outset Nicholas himself was fully aware of this. Shortly after 1917 his sister, the Grand Duchess Olga Alexandrovna, wrote how the young tsar sobbed on his father's death that he 'didn't know what was going to happen to

us all, that he was totally unsuited to being a tsar'. 'And my father bears some blame for this', Olga continued, 'because he did not familiarize his successor with matters of state. And what a terrible price had to be paid for that error.'

The same observation is found in the reminiscences of Grand Duke Alexandr Mikhailovich, a boyhood friend of the tsar, who knew him well. He saw the death of Alexander III as a dreadful catastrophe, that led to 'the fate of one-sixth of the world' falling into 'the trembling hands of a stripling who was easily upset'. 'If Nicholas had been born of ordinary mortals he would have led a perfectly harmonious life, approved of by his superiors and respected by those around him. He was an ideal family man and believed in the weight of an oath he had sworn. It was not his fault that fate turned these good qualities into deadly weapons', the Grand Duke stated.

The French ambassador Maurice Paléologue, who had many conversations with him towards the end of his reign, wrote a sharp and revealing comment on him, 'I don't know who it was who said about the tsar that he "had all the vices and not a single failing". Nicholas II did not have any vices, but for an autocrat he had the very worst possible shortcoming, namely a lack of personality. People were able to avoid, deceive or dominate him at will.'

By nature he was a gentle man, with a weak character, who frequently went back on his decisions or *ukases*; he was an 'irreproachable family man', who preferred the intimacy of family life and the company of his wife and children to affairs of state. He clearly regarded his duties as a monarch as a burden. Moreover, as many who knew him remarked,

CAT. NR. 183
FAN, *1886*
Ivan Nikolayevich Kramskoi (*1837–1887*)
Russia, St Petersburg
wood, silk, gold, mother-of-pearl, carving, oil paint

CAT. NR. 14 (next page)
THE WEDDING OF TSAR NICHOLAS II
AND TSARINA ALEXANDRA FYODOROVNA, *1895*
Laurits Regner Tuxen (*1853–1927*)
Oil on canvas

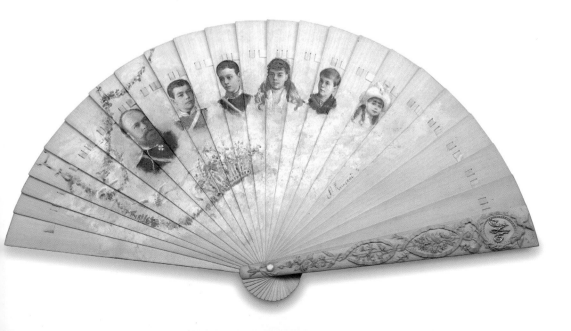

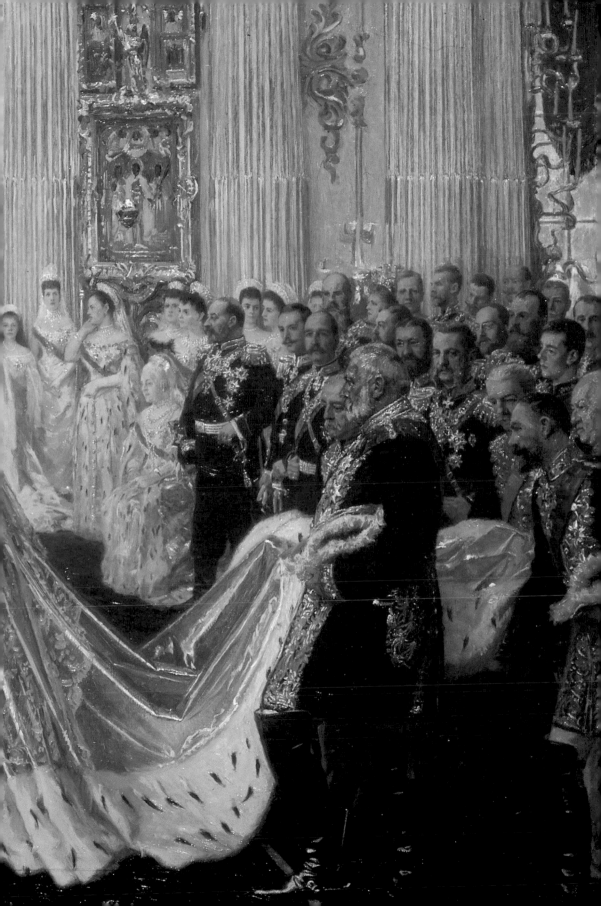

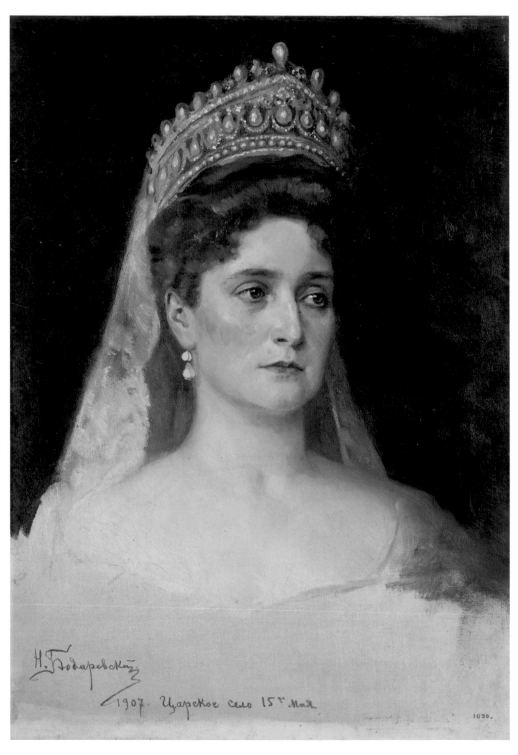

he was a fatalist and 'submissive to fate in mystical fashion'. '(...) He is a fatalist. He is weak', wrote one of the most influential women at the court, the Grand Duchess Maria Pavlovna, the wife of his uncle Grand Duke Vladimir Alexandrovich. 'Instead of taking some form of action when things go wrong, he persuades himself that God has willed it so, and he then proceeds to surrender to God's will!'

Another picturesque but very harsh description was that of the malicious publisher Alexei Suvorin: 'Alexander III tamed a Russian mare. Nicholas II has harnessed an old nag. He moves, that's for sure, but where? Where chance takes him!' Nor should we gloss over the tsar's purely human tragedy, the appalling sickness of his only son and heir Alexei. The latter's haemophilia affected much of the tsar's conduct and, strange as it may seem, it played a decisive role in Russian history.

The artist Alexandr Benois recalled that when he heard the gunshots proclaiming the birth of the long-awaited heir to the throne, like 'millions of my contemporaries' he thought, 'God grant that our future tsar is closer to the ideal of a monarch than his father; who, for all his charm, has by now frittered away the love and loyalty of his subjects. But fate had a terrible and tragic reply to this hope. Instead of dying a martyr's death, the child who was born that day was condemned to be the unasked-for cause of years of unremitting suffering for his parents; due to

his fateful sickness the ghastly shadow of Rasputin loomed over the memory of his father and mother – he alone possessed the magic power to stop the bleeding that the unhappy boy suffered from. And yet it was such a bright and joyful day!'

Alexei's tutor, Pierre Gillard, who was with him almost till his final moments in Ekaterinenburg, also wrote, 'The sickness of the Grand Duke and Heir to the Throne dominated the whole of the last years of the reign of Nicholas II.' Nicholas's wife, the tsarina Alexandra Fyodorovna, whom he loved all his life and to whom he subordinated himself almost stoically, also played a distinctly negative role in the fate of both her family and that of Russia. She was a princess from the little Duchy of Hesse-Darmstadt, who adopted the orthodox faith on moving to Russia and was given the name Alexandra Fyodorovna – Alix, as she was called by her family. Everyone who saw her praised her exceptional beauty. The daughter of Pyotr Stolypin, for instance, Maria Bok wrote, 'I gazed ecstatically at the young tsarina, who was amazingly beautiful in her pale attire, glittering with diamonds. This is how I would imagine a fairy out of a fairytale. She was a beauty, a Russian tsarina in greatness and dignity.'

According to the head of the secretariat of the Ministry of the Imperial Court, despite being a loving wife and marvellous, if unfortunate mother, she could 'never become a genuine tsarina due to her personal situation, and that is a great pity, because with her hard character she could have been of great assistance to His Majesty. Unfortunately her ideas were even more bigoted than those of His Majesty, so that her support of Nicholas did him more harm than good.' She was dif-

BLUEBERRY TWIG IN A VASE,
1880–1890
Unknown Master, Fabergé
Gold, nephrite, azure, rock crystal,
casting, polishing, carving, chasing

CAT. NR. 135

ferent from her sister the Grand Duchess
Elizaveta Fyodorovna, the wife of Grand
Duke Sergei Alexandrovich who, again in the
words of Mosolov, 'had become completely
Russian in heart and soul after a couple of
years in the country, while the tsarina,
although she loved Russia, never succeeded
all her reign in understanding the Russian
soul and could not instil in herself a love for

Russia, as her sister did.' By nature she was
very reserved and severe and awkward in her
dealings with people, only feeling at ease
within her family. She cared little for the
court or for St Petersburg society. She only
attended court balls and receptions of the
aristocracy of the city with any frequency
during the first years after her marriage;
from then on her public appearances became
increasingly rare. She was incapable of making
drawing room conversation, nor did she
know how to smile at the proper moment or
say something kind or friendly, all she could
manage was some meaningless word, and
her character set the court against her. Grand
Duke Alexandr Mikhailovich remarked that,
'By distancing herself from the complicated
goings-on at the court the young tsarina
made mistakes that in themselves were
trivial, but which constituted dreadful mis-
demeanours in the eyes of the St Petersburg
beau monde. She was shocked by this attitude
and this led in turn to that typical stiffness of
hers towards her milieu. Nicholas II took
this to heart, and presently relations between
the court and the upper classes took on a very
strained character.'

The tsarina's character was excellently
captured by the young page Boris Gerua, who
was working in the Winter Palace at the
time of Nicholas II's marriage and who went
on to become a major-general with the
General Staff: 'She [the tsarina] finally
arrived with her sister Grand Duchess
Elizaveta Fyodorovna, a quite exceptional
beauty. Alexandra Fyodorovna too was beau-
tiful and stately; she looked very much like
her sister, but could not compare with her.
We went to meet them at the carriage door
and helped them out. The Grand Duchess

and bride gave us her hand to kiss, but did so with an awkward and embarrassed gesture. A sense of unease was thus the first thing you noticed on meeting the young tsarina, and this impression she never managed to dispel. She was so obviously nervous of conversation and at moments when she needed to show some social graces or a charming smile, her face would become suffused with little red spots and she would look intensely serious. Her superb eyes promised kindness, but instead of a bright spark, they contained only the cold embers of a dampened fire. There was a certain purity and loftiness in the look, but loftiness is always dangerous; it is akin to pride and can quickly lead to alienation.'

EX CATALOGUE (left)
FLOWER VASE, *1900-1910*
Master Yuli Alexandrovich Rappoport
glass

CAT. NR. 138 (below)
DISH WITH TWO HANDLES,
1880–1890
Master Erik August Kollin, Fabergé
agate, almandines, silver, carving,
chasing, gilt, blacking

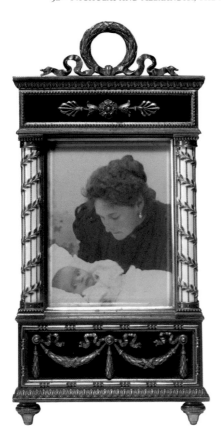

Frame with photo of Tsarina
Alexandra Fyodorovna and
her daughter Tatyana, *1890-1900*
Master Michail Yevlampievich Perchin,
Fabergé
silver, gilt, enamel, bone, photo

CAT.NR. 121

The tsarina's reserve and her distaste for fashionable life became particularly apparent after the birth of her incurably sick son. The long-expected heir only arrived in 1904 after ten years of marriage and the birth of four girls. During this period Alexandra Fyodorovna was like a very sick woman: her heart and nerves were sick, she had frequent bouts of hysteria, her legs were weak, making it impossible for her to go off with her husband and children on their many walks.

It was understandable. She was a mother who knew she was the cause of her son's disease – it was only passed on through the female line, in this case through Queen Victoria of England who 'rewarded' many of her descendents in this way. Moreover she was a mother who was powerless to alleviate her son's agony when he was screaming with pain. She suffered endlessly – hence her trust in anyone who promised help, after she had lost faith in all doctors. Hence too her boundless faith in Rasputin, who unquestionably possessed paranormal gifts and was the only one who was able – even at a distance – to stop the poor child's blood from flowing and cure his sufferings. It was above all this that explains that 'dreadful shadow of Rasputin' which in the words of contemporaries 'was cast over Russia', his seemingly strange influence on the tsarina and, through her, on Nicholas II and those extreme requests or rather demands of the *starets*.

Because he witnessed the distress of his son and his wife, Nicholas permitted Rasputin to come to Tsarskoe Selo. Stolypin told his daughter that he 'warned the tsar every time he did so. But this was what he said to me recently: "I agree with you, Pyotr Arkadyevich, but I'd rather have ten Rasputins than one hysterical tsarina. Of course that explains it all. The tsarina is ill, seriously ill. She believes the only person in the whole world who can help the heir is Rasputin, and it is humanly impossible to persuade her otherwise. Because in general it is already very difficult to talk to her..."'

One of the oddities in the tsarina's view of life which, in the words of the minister of Finance Vladimir Kokovtsov, she 'acquired together with her religiosity and which she

gradually began to experience as pure politi-
cal dogma, was her belief in the steadfastness,
invincibility and permanence of the Russian
autocracy, as it had developed over three hun-
dred years. In her political beliefs the tsarina
was more absolutist than the tsar. She was an
unqualified advocate of the principle of a
strong state, with the tsar as it were as the
basis and justification of his own ideas.'

To realize how unlimited an influence
Alexandra exercised on the tsar, one only

needs to read their correspondence during
the First World War, at the most stressful
point in Russian history, when Nicholas was
stationed in the Headquarters in Mogilyov
[now in Belarus]. Like a refrain running
through these letters is her unshakeable faith
in the notion of an unbridled autocracy.
'Don't forget that you are the absolute
monarch and that this is what you must be!
We are not ready for a constitutional govern-
ment', she wrote on 17 June 1915, when the
question of the introducing a constitutional
monarchy was becoming urgent.

None of her letters showed any under-
standing of developments on the ground in
Russia. They betrayed instead that she was
entirely under the control of Rasputin and

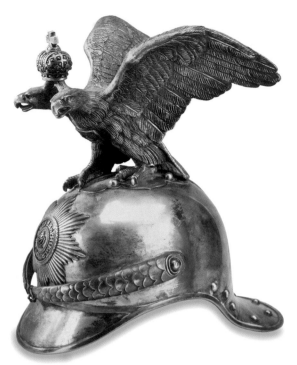

HELMET OF A PALACE GUARD
Russia, 19th century
metal, gilt

EX CATALOGUE

his clique. She alluded for instance to the opinions of 'our friend' and passed on his requests and demands to give posts in ministries to new people and to get rid of old ones. Nicholas did not refuse, and the result was a rapid turnover of ministers with almost all the members of the government losing their jobs. Unlike predecessors such as Catherine the Great or Alexander II, Nicholas could not or would not surround himself with sensible practically-minded people who might have given him good advice and even changed the course of history. People like Sergei Witte, Pyotr Stolypin, Vladimir Kokovtsov and Sergei Sazonov did not retain their posts for long, and left for one reason or another. At the prompting of Rasputin,

untalented and reactionary people were appointed in their stead – Ivan Goremykin, Alexandr Trepov, Boris Stürmer, Nikolai Golitsyn and others. 'Our friend is asking you to repeal the Duma', Alexandra wrote on 14 February 1916, when the autocracy was on the edge of the abyss, '(...) be Peter the Great, Ivan the Terrible or Tsar Paul, crush them all, don't laugh (...) I'd just love to see you acting like that against those people who are trying to control you.'

Even the majority of members of the large and heterogeneous Romanov family, of which the tsar was the head and which comprised sixty-one members in 1913, saw the need for change. The tsar was approached in their name by his uncle, Grand Duke Nikolai Mikhailovich, to give him this advice. But Alexandra continued to pressurize him: 'Show them all that you are the ruler. Gone are the days of leniency and being nice, now is the time for your autocracy of will and power! They [the family] will have to learn to feel guilty (...). Why do they hate me?'

'Right from the start she misjudged the situation', wrote the English ambassador George Buchanan. 'By encouraging the tsar to stick to a course that was full of dangers for the ship of state, while the political waves had already reached dangerous heights, she proved the perfect means for its downfall. If his wife had had a broader vision and greater

SENTRY OF THE CAVALRY
REGIMENT OF GUARDS AT THE
WINTER PALACE, *1889*
Narkiz Nikolayevich Bunin
(1856–1912)
oil on canvas

CAT. NR. 03

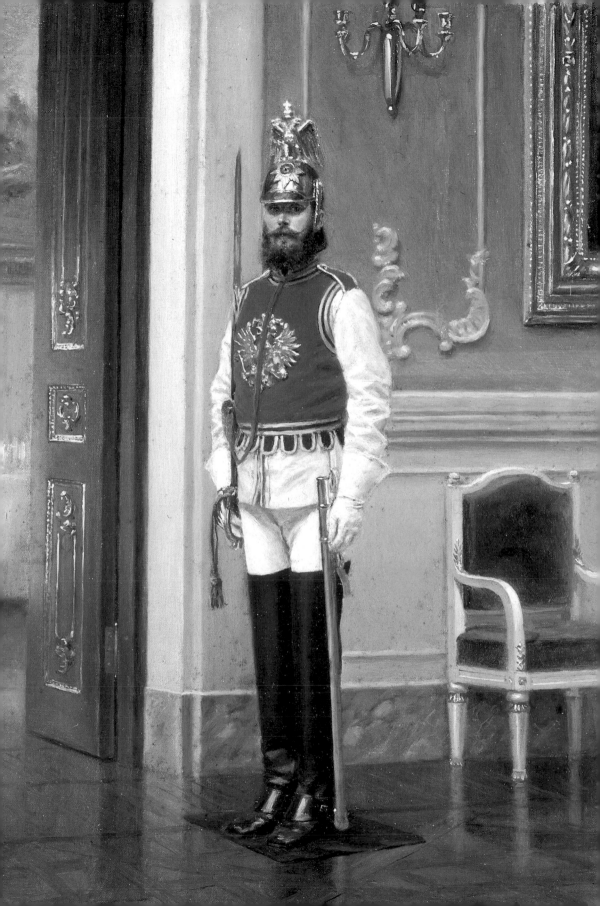

shrewdness and had understood that a regime like this was an anachronism at the beginning of the twentieth century, the history of his tsardom would have been different.'

The problem lay partly in Nicholas's character, his ardent faith in his predestination as absolute ruler of Russia, as 'God's anointed' that made him unwilling to compromise. It was aggravated by his almost stoical submission to his wife, who in her turn was under the spell of Rasputin, supporting his reactionary group at the court – the 'Camarillas' as contemporaries called them. Nicholas lacked all flexibility as a

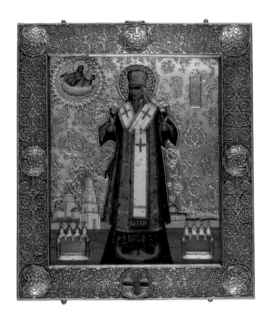

CAT. NR. 29 (left)
IOASAPH OF BELGOROD, *1911*
K. Yemelyanov *(icon)*
Ivan Petrovich Chlebnikov firm, Moscow *(silver filigree frame)*
panel, oil, mica, brocade, silver, filigree

CAT. NR. 30 (right)
THE FEODOR MOTHER OF GOD, *1913*
Vasili Pavlovich Guryanov *(icon)*
Dmitri Lukich Smirnov studio, Moscow *(frame)*
panel, silk, silver, tempera, enamel, filigree

CAT. NR. 28 (right page)
THE LOYAL PRINCE ALEXANDER NEVSKI,
THE MIRACLE WORKER ST TITUS AND
THE MARTYR ST POLYCARPUS, *1879*
Vasili Vasilyevich Vasilyev *(1829–1894) (icon)*
Ovchinnikov firm, Moscow *(frame)*
panel, oil, silver, diamonds, pearls, enamel, engraving, piercing, gilt

politician and in the words of Grand Duke Alexandr Mikhailovich, he headed 'straight for the abyss, thinking that it was the will of God'. And yet, all the tragic circumstances in the life of the tsar and his family and 'the tragic events in Russia, that followed on top of each other ever more rapidly under his rule, could not break through the dense confusion of tsarist usages or bring any change in the strictly defined protocol'. Official life at the Russian court continued to flow in its official channels, conspicuous as before for its luxury and splendour.

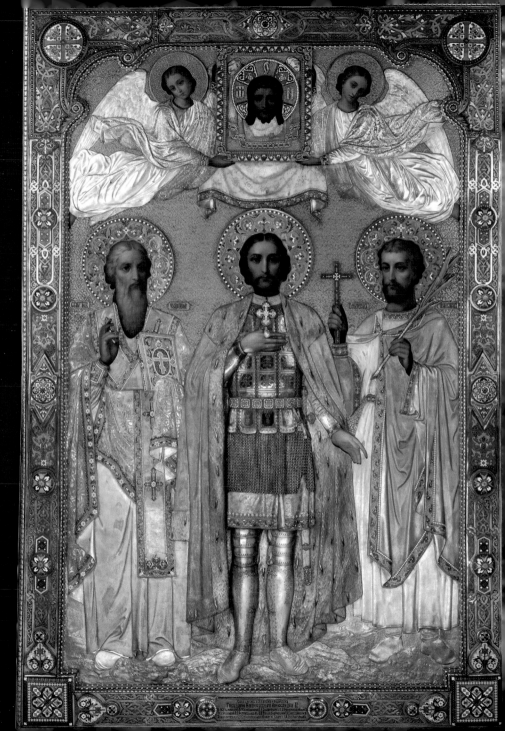

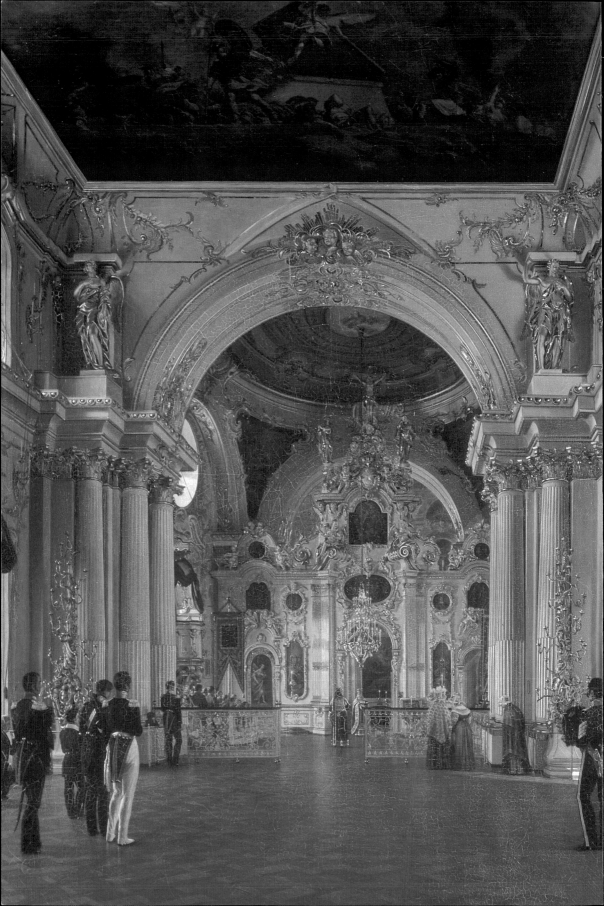

'While he was extremely modest and simple in his private life, observed Grand Duke Alexandr Mikhailovich, 'the tsar had to comply with the requirements of etiquette. The ruler of a sixth of the globe had no choice but to receive his guests in an atmosphere of profligate luxury.' And maybe that was the thing that most amazed the foreign diplomats and everyone else who was received at court. Alexandr Mikhailovich goes on to describe one of the balls in the Winter Palace. 'Enormous halls, decorated with mirrors with gilt frames, were crowded with dignitaries, courtiers, foreign diplomats, guard officers and oriental potentates. Their splendid uniforms, adorned with silver and gold, served as the magnificent background for the court costumes and precious objects worn by the ladies. Cavalrymen of the guard wearing helmets with the two-headed eagle of the tsars and Cossacks of His Majesty's own escort in Circassian uniforms lined the staircase and crowded the entrance of the Nicholas Hall. The room were adorned with countless palms and tropical plants from the court orangeries. The dazzling light of the great

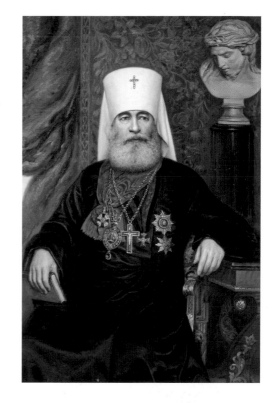

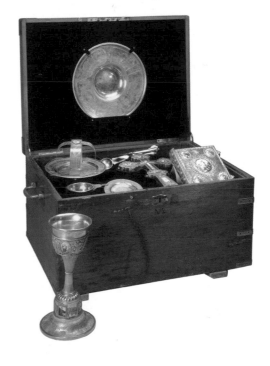

CAT. NR. 16 (left)
INTERIOR OF THE CATHEDRAL AT
THE WINTER PALACE, *1829*
Alexei Vasilyevich Tyranov *(1808–1859)*
oil on canvas

CAT. NR. 06 (above right)
PORTRAIT OF METROPOLITAN ANTONY, *1911*
Andrei Andreyevich Karelin *(1866–after 1911)*
oil on canvas

CAT. NR. 117 (right)
COMMUNION SET FROM THE FIELD CHURCH
OF TSAR ALEXANDER I, *1812*
Master Axel Hedlund, St Petersburg,
after a design by Andrei Voronikhin
silver, gilt, enamel, paper, casting, carving, engraving

CAT. NR. 81 (right)
SMALL DINING ROOM, *1917*
Karl Karlovich Kubesch
(late 19th/early 20th century)
photo

CAT. NR. 80 (bottom)
SOLDIERS IN THE MINISTERIAL RECEPTION ROOM
OF NICHOLAS II AFTER THE STORMING OF
THE WINTER PALACE, *1917*
Karl Karlovich Kubesch
(late 19th/early 20th century)
photo

CAT. NR. 74 (right page, up)
ALEXANDRA FYODOROVNA'S BOUDOIR, *1917*
Karl Karlovich Kubesch
(late 19th/early 20th century)
photo

CAT. NR. 83 (right page, bottom)
ALEXANDRA FYODOROVNA'S BOUDOIR.
AFTER THE STORMING OF THE PALACE, *1917*
Karl Karlovich Kubesch
(late 19th/early 20th century)
silver bromide print

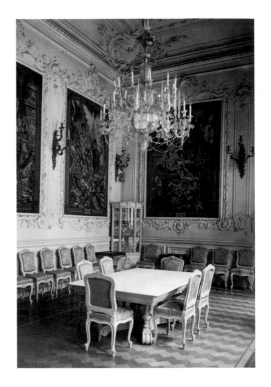

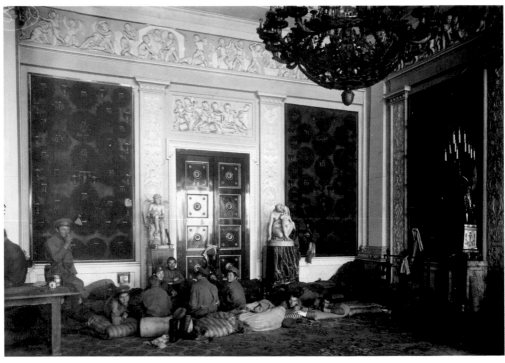

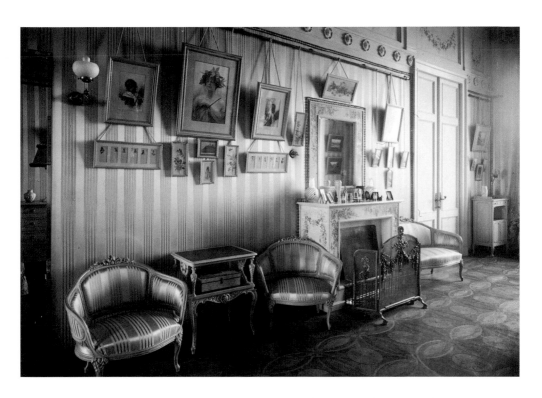

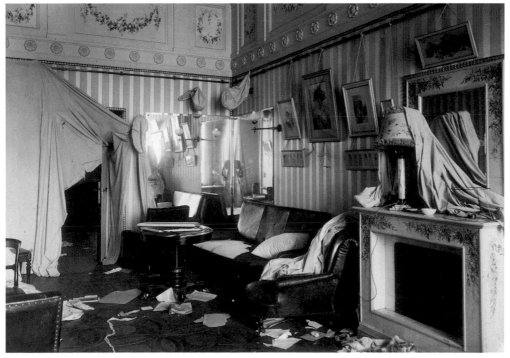

chandeliers reflected in many mirrors, gave the whole scene an immensely enchanting character. Gazing at the sumptuously furnished Nicholas Hall you forgot the functional twentieth century and were swept away to the brilliant age of Catherine. (...) And suddenly the whole crowd fell silent. The head master of ceremonies appeared and tapped three times on the floor, to announce the Entry of His Highness. The massive floor of the hall swung open, and on the threshold the tsar and tsarina appeared, accompanied by their family and retinue.'

The French ambassador, Maurice Paléologue, also gives an essential description of the tsar's court. Writing about a reception for the French president Raymond Poincaré on his visit St Petersburg in June 1914, he says: 'At half-past seven a banquet was held in the Tsarina Elisabeth Hall [in the Palace of Tsarskoe Selo]. In the opulence of the uniforms, the extravagance of the dress of the ladies, the richness of the liveries, the sumptuousness of the costumes, the entire display of splendour and power, this spectacle is so magnificent, no court in the world can vie with it. I will long remember the dazzling brilliance of the jewels strewn over the ladies' shoulders. It was a fantastic river of diamonds, pearls, rubies, sapphires, emeralds, topazes, beryls: a river of light and fire.'

This was of course purely an impression of the exterior of something called the 'Russian court', of a traditional ceremonial that had its origins in the eighteenth century and which had remained virtually unchanged over nearly two hundred years. It was remarkable moreover to see it combined with all the novelties of the twentieth century – telephones, telegrams, films, cars and electricity.

Full dress was obligatory at court, especially the 'Russian' or 'uniform dresses' that ladies wore to balls and official receptions. Strict regulations had already been prescribed for such matters by Nicholas I in 1834, and they remained unchanged apart from a few insignificant adjustments until 1917. The obligatory costumes for court officials who were invited to official ceremonies and for palace servants (valets, court negroes, pages, and others) were an indispensable ritual element in court life. Strictly regulated too was the group of people who attended the great and small processions of the tsar and his family from their private apartments in the Winter Palace to the public rooms or the church, with everyone knowing who would walk with whom. Official processions from the palace, obligatory attendance at garrison feast days (especially when the commander was a member of the tsar's family), visits to openings of exhibitions, the consecration of new churches and other major social events were also bound by this solemn ceremonial.

Particularly solemn were the processions to the church of the Winter Palace on days of major religious festivals such as Easter and Christmas. As said above, both Nicholas and Alexandra were deeply devout. In the private apartments of all their palaces were innumerable icons, placed on special screens or hanging on the walls, adorned with Easter eggs suspended by ribbons. As Yuri Danilov wrote, in the private railway car of the tsar there was 'a whole chapel of large and small icons and a variety of devotional objects (...). He [the tsar] never missed any services, any more than Alexandra did, who spent hours on her knees, praying for the health of her son and family.

TWO EASTER EGGS, *1850-1900*
Lukutin Family Factory, near Moscow
papier-maché, oil paint, painting, gilt, lacquer
At Easter Nicholas & Alexandra gave each other
precious Easter eggs. These more simple ones were for
other family members and friends and acquaintances.

CAT. NRS. 156 AND 157

Every palace of the tsar had its court church. In the Winter Palace, which was the most important residence, there were even two, the Great and the Small Churches of the Saviour, built after a design by Francesco Rastrelli and rebuilt almost unchanged by the architect Vasily Stasov after a fire of 1837. This church was marvellously elegant and brilliant with the gold leaf of its magnificent interior and superbly carved iconostasis. We should remember that the Russian monarch was also the head of the orthodox church and that this was also a reason why the most solemn masses were held specifically in the great church in his residence. In the richness of its interiors and the luxury of the gold and silver objects and its vestments adorned with many precious stones, the Russian church vied in splendour with the court.

The services were usually accompanied by the choir of the court chapel or else occasionally, the metropolitan choir. During services, according to Paléologue, one could hear 'marvellously beautiful hymns, sometimes broad and mighty, or else tender and ethereal, expressing better than any words the infinite aspirations of orthodox mysticism and the Slav sensibility'.

But as early as the second decade of the century – and this was mainly a result of the outbreak of war, the luxury and brilliance of

the Russian court and the church services gradually began to decline. As mentioned above, the tsar and his family lived in Tsarskoe Selo after 1905 and only went to the Winter Palace on days of special celebrations and church festivals. 'In those years there were no longer any receptions at the court', wrote Maria Bok, 'so that I only know of the brilliant balls in the Winter Palace and the Anichkov Palace from the stories of the older generation.'

I will quote Paléologue again by way of epilogue. He tells that that a few days after the abdication of Nicholas II (2 March 1917) he 'met one of the "Ethiopians" in the summer gardens who had so often shown me into the tsar's office. The friendly Negro wore civilian dress and his face was sad. He had tears in his eyes. (...) In this dismantling of a whole political and social system he represents for me the former luxury of the tsars and the picturesque and splendid ceremonial, as established by Elisabeth and Catherine the Great. From now on the Russian court and all the enchantment this phrase evoked no longer mean anything.'

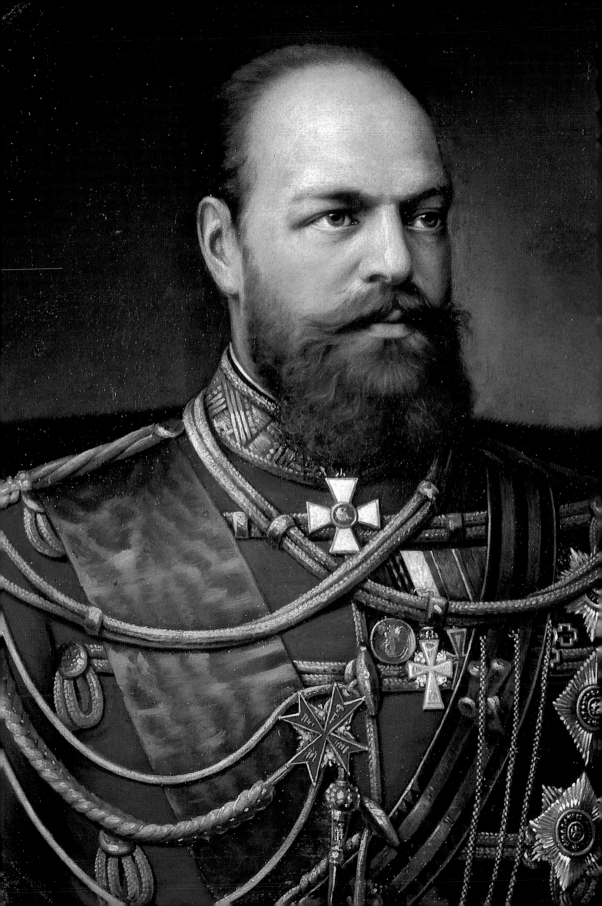

Galina Printseva

THE
CORONATION
of Nicholas II

Portrait of Tsar Alexander III,
late 19th century
Unknown Artist
(second half 19th century)
oil on canvas

CAT. NR. 21

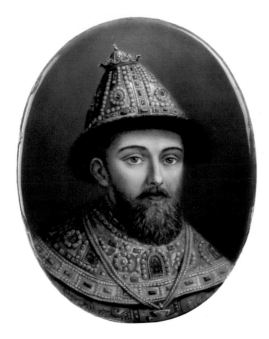

PORTRAIT OF TSAR MICHAIL FYODOROVICH, *c. 1913*
Unknown Artist *(early 20th century)*
silver, enamel, fresco

CAT. NR. 42

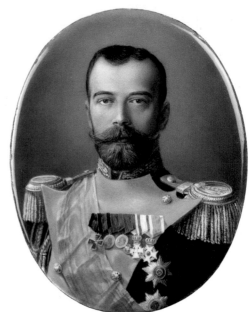

PORTRAIT OF TSAR NICHOLAS II, *c. 1913*
Unknown Artist *(early 20th century)*
silver, enamel, fresco

CAT. NR. 41

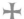

The coronation of a new tsar was the most important national event in pre-Revolutionary Russia. Until this ritual had taken place the monarch was not considered definitively to have assumed power; only the Church in the person of its highest dignitaries was able to invest the tsar with his supreme authority. Through this ceremony the profound faith of tsar and people were initiated in the divine nature of power. It was with good reason then that the coronation was referred to as 'holy'.

The crowning of the last representative of the Romanov dynasty is particularly interesting. The ceremony was held in the former capital, Moscow – still the religious capital – in the Assumption Cathedral in the Kremlin. Beginning with the reign of Ivan IV (the

Terrible) in the sixteenth century, this was the traditional scene for the coronation of Russian tsars. The ceremony did not coincide with the accession to the throne. First of all the period of mourning for the former tsar had to be completed; secondly it was not permitted to disturb other state events. Account also had to be taken of the time of year. Spring and summer for instance were suitable for the street festivities and processions that accompanied the coronation.

Nicholas II set his coronation for May 1896. The twelve months period of mourning for Alexander III was over and the new tsar, who cherished his father's memory, decided to have himself crowned in the same month as Alexander's coronation thirteen

years before. The solemnities lasted three weeks from the arrival of the imperial family in Moscow, from 6 to 26 May. Nicholas's coronation as tsar took place on 14 May. The programme for each day was planned according to protocol. The days prior to the arrival of the tsar and tsarina in Moscow were taken up with preparations.

The manifesto for the coronation was issued in January 1896. A committee was set up at the same time to prepare the event, with the governor general of Moscow, Grand Duke Sergei Alexandrovich, the uncle of the young tsar presiding over it. His wife, Grand Duchess Elizaveta Fyodorovna, née princess of Hesse and sister of the tsarina, gave him more than mere moral support, practically taking on the work of secretary. She wrote to the Grand Duke Konstantin Konstantinovich, their friend, a nephew of the father of the tsar and commandant of the Preobrazhensky guard regiment: 'We must remember everything. But meanwhile difficulties are piling up ...' Not only did the programme and ceremonial for each day need planning, the city had to be decorated and grandstands built in the Kremlin and along the route of the coronation procession. Seating arrangements and an order of precedence had to be drawn up for the many envoys of European and Asiatic courts, the members of the Tsar's family, the guests from other Russian cities, sections of the guard regiments and journalists and artists. Finally order had to be guaranteed in the streets of Moscow. The work of decorating the city, especially the decorations and illuminations for the Kremlin, required thousands of building workers and engineers. In short the task was enormous.

On 3 April, a month before the solemnities, the tsar's regalia were transported by special train from the Winter Palace in St Petersburg to the Armoury in the Kremlin: the large and small crown, the sceptre and the mace, the coronation robes, the parade insignia; On the eve of the coronation they were brought to the Throne Room of the Kremlin, and from there to the Assumption Cathedral. At the end of April the first units of the guard regiments, who played a role in the ceremony, arrived from St Petersburg. Every day new garrison troops arrived in Moscow, transforming it from the seat of government into a garrison town, from a Russian city into an international one. The coronation of Nicholas II was the first to be

PORTRAIT OF GRAND DUCHESS ELIZAVETA FYODOROVNA, *1885*
Carl Rudolph Sohn (*1845–1908*)
oil on canvas

CAT. NR. 05

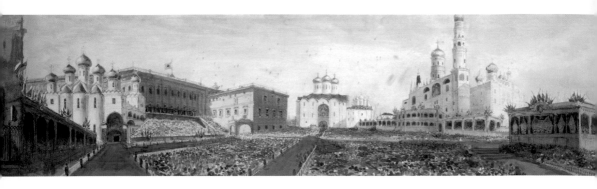

attended not just by the delegates of all the orthodox patriarchs, but also those of the Vatican and the Anglican church. Eastern States, including China, were significantly better represented than at the coronation of Alexander III in 1883. From press reports we learn that it was attended by one queen, three grand dukes, two reigning monarchs, twelve crown princes, sixteen princes and princesses – not to mention the many members of the Romanov family. The lavishness of the preparations for this event surpassed all previous coronations, as though there was a premonition that this would be the last to be held in Russia.

More than two hundred correspondents and artists converged on Moscow and a special building was vacated to accommodate them. The Imperial Art Academy had appointed Viktor Vasnetsov, Vladimir Makovsky, Valentin Serov, Ilya Repin, Andrei Ryabushkin and Mikhail Nesterov to sit in the stands and make sketches for the coronation album. The occasion was portrayed in miniatures by Isaac Levitan, Nikolai Karazin, Mikhail Zichi, Nikolai Samokish, Alexandr Pervukhin, Elena Samokish-Sudkovskaya, Earnest Lipgart and others. They produced decorative work for documents, programmes, invitations and menus. A photographic album with scenes of the coronation was made by the court photographer Karl von Hann and many other photographers. Finally, the coronation of 1896 was the first major government occasion to be recorded on film. In April 1897 'living photographs' were shown for the first time in St Petersburg, nineteen moving pictures according to the cinematographic principle of the Lumière brothers.

Despite the large number of artists and correspondents only twenty seats were set aside for them at the coronation itself. One of them was Pavel Yakovlevich Pyasetsky, who created one of the most impressive testimonies of the event – an enormous 58-metre panorama, depicting the most important moments from the arrival of the tsar and tsarina on 6 May to their departure from Moscow on May 26.

Pyasetsky, an eminent geographer, ethnographer, doctor and artist was a close acquaintance of Nicholas II. His panoramas, the

(this page and following pages)
PANORAMA OF THE CORONATION CELEBRATIONS
FOR NICHOLAS II AND
ALEXANDRA FYODOROVNA, *1896–1900*
Pavel Jakovlevich Pyaietski (*1843–1919*)
watercolours, paper

EX CATALOGUE

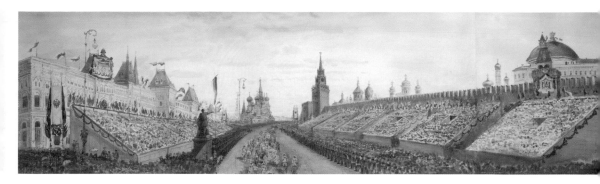

record of his geographical and military expeditions to China, Bulgaria and Central Asia had already been exhibited under Alexander II and Alexander III. He was a traveller and geographer by vocation, but his talent as an artist allowed him to make rapid sketches *en route* on the basis of which he produced panoramic watercolours of up to a hundred metres in length. He then pinned them onto a canvas to make then easier to view. By winding the canvas round a cylinder and then unwinding it frame by frame, he created the illusion of a curious manually-operated film. Moving panoramas like this were also made in this period by artists from other countries, but in Russia they are linked exclusively with the name of Pyasetsky.

He had asked the Minister of the Imperial Court for permission to make this corona-tion panorama back in December 1895 and this was duly granted: 'The ever-friendly opinions about my works, and in particular the kind interest taken in some of them by the Emperors Alexander II and Alexander III embolden me to ponder on how happy I would be if I could present some of them to his Imperial Highness, and certainly if you put in a good word for me to get leave to compose a new work, a Panorama of the Holy Coronation of Their Royal Highnesses.

'If I do indeed get leave to do this, then I feel obliged to request that you show me the best vantage-points for the depiction of the materials. Part of this can be done some time in advance, as for instance the costumes, the architecture of the building and the streets from special angles, etc.. I will also need to know the programme of the ceremonial by

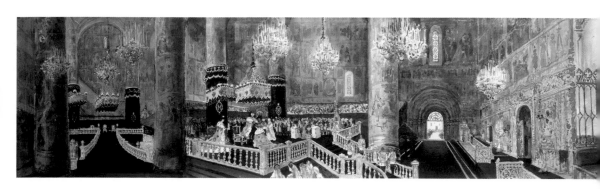

which the events will occur. A painting like this, if I succeed in making it, would be a most welcome work for all the inhabitants of the cities and villages of our fatherland.'

P. Pyasetsky, doctor in medicine

Today the painted panorama is a unique record of the event. It takes viewers through the ceremony step by step, informing them of the correct sequence of events.

On 6 May 1896 the train carrying the Tsar and his wife arrived in Moscow. A lavish pavilion adorned with flowers and tropical plants and furnished with French-style furniture on a velvet carpet was built on a platform to welcome them.

'We arrived in Moscow at five o'clock. The weather was dreadful – rainy, windy and cold. On the platform we were welcomed by the guard of honour of the Ulansky regiment. From there we rode with an escort of all the cavalry officers to the Peter Palace', Nicholas wrote in his diary. On the same day Moscow celebrated the tsar's birthday. A solemn mass was celebrated in the Church of Christ the Saviour. According to a tradition that began with Paul I (1796-1801), the Peter Palace just outside the city was used as the residence for the foreign statesmen before the solemn entry into Moscow for the coronation. Nicholas and Alexandra stayed there for three days to receive the princes and Oriental rulers and their entourages who had come specially for the occasion.

On 9 May 1896 the solemn entry of the tsar into Moscow took place. 'The first heavy day for us – that of the entry', wrote Nicholas. 'The weather was now marvellous.

At twelve the whole group of princes, with whom we were to have breakfast, assembled. At about half-past three the procession started off. I rode on Norma. Mama sat in the first golden coach, Alix in the second, also alone. As for the meeting, there is nothing to say about it; it was as solemn and warm-hearted as only Moscow is capable of!'

A huge crowd of people had gathered on and between the stands along the whole route of the procession from the Peter Palace to the Kremlin – through the Triumphal Arch, along Strastny Boulevard and the whole length of Tverskaya Street, lavishly decorated for this occasion. The garrison troops stood drawn up in two ranks. All the windows, balconies and rooftops were packed with people.

'It was just after two when a shot finally rang out from the Kremlin, proclaiming that His Highness the Tsar had left the Peter Palace. Everyone bared their heads and crossed themselves devoutly. Immediately after the shot all the church bells of Moscow began to ring in unison. First a convoy of men in uniforms of various colours appeared, followed by the other participants in the procession, according to the ceremonial'

This is how the artist Mikhail Nesterov described the event in his diary: 'The garrison troops stood at attention, music began to play, and the young tsar appeared on a white Arab horse. He rode slowly, greeted the people affectionately; he was excited, with a pale, emaciated face. The tsar then rode on through the Spassky gate and into the Kremlin.' Behind him the tsarinas rode in their carriages, with the other members of the imperial family.

One trivial detail that the youngest sister of the tsar, Princess Olga Alexandrovna recalled is worth mentioning. She also rode in one of the gilded coaches, that looked so beautiful, but 'were a torture chamber' inside. The springs were poor and nobody had thought of providing ventilation. The girl sat between her aunt, the Queen of Greece Olga Konstantinovna and her cousin, Crown Princess Maria of Romania. The three of them nearly fainted for lack of oxygen, and were terrified that their arms and legs would break with all the jolts.

The cortège came to a final halt inside the Kremlin, where the tsar and tsarina visited the three most important churches in the city – the Cathedrals of the Assumption, the Archangel and the Annunciation. The latter one was missed out however, due to an error of the clergy leading the procession. The tsar's entourage, that kept a close eye on every detail of the ceremony, thought that this cast a shadow over the occasion. But the real tragedy was yet to come.

Pyasetsky's panorama recorded all the main moments of the coronation from the arrival of the tsar by train to his entry into the Kremlin. The festive decorations along Nicholas's route into Moscow was particularly colourful: flags, banners, garlands, decorative obelisks, the spectators' stands and the special pavilions; all this made the centre of Moscow festive as it had never been. In order for the panorama to depict

(next page)
THE CORONATION OF TSAR NICHOLAS II AND
TSARINA ALEXANDRA FYODOROVNA, 1898
Laurits Regner Tuxen (1853–1927)
oil on canvas

CAT. NR. 15

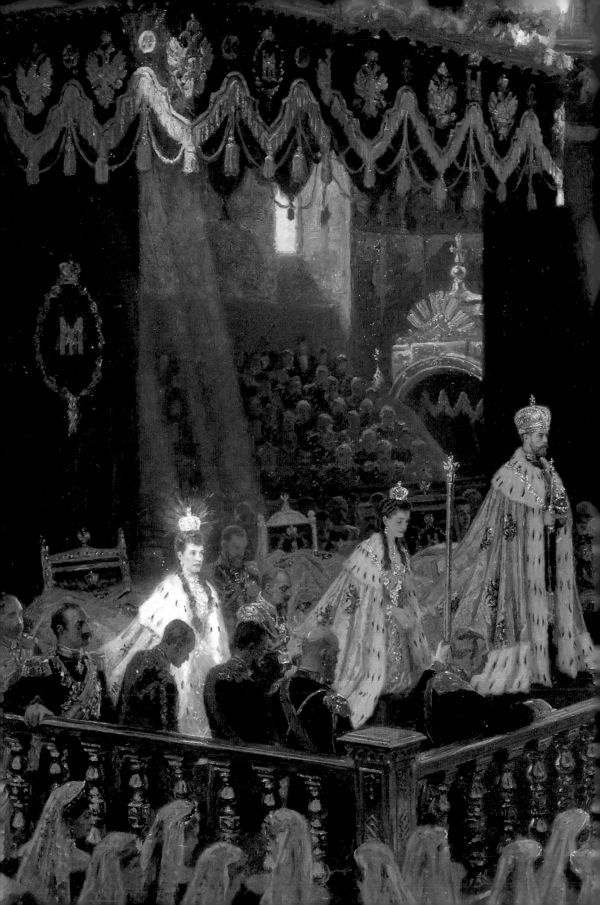

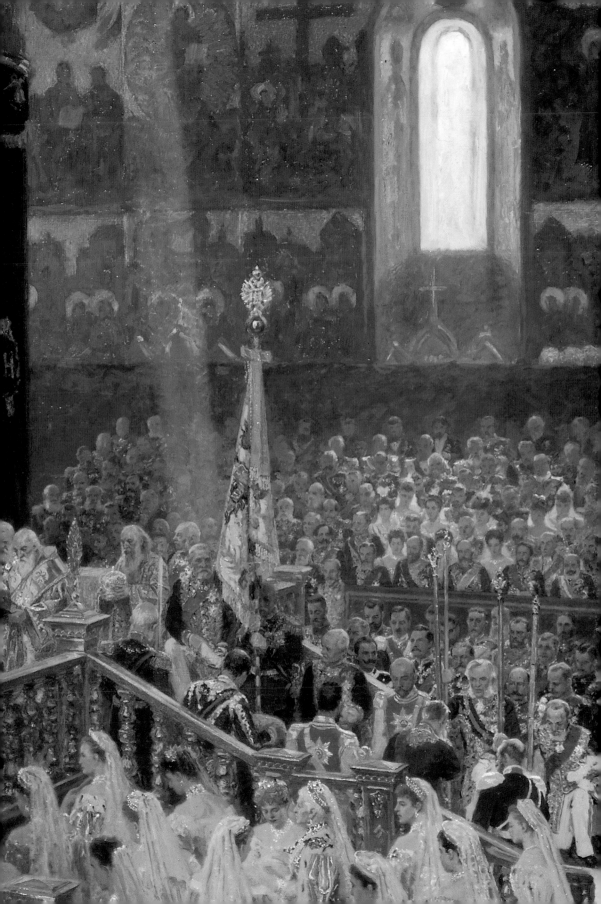

Moscow in as much detail as possible, the artist depicted the scene from both banks of the Moskva River: first one sees the far side from the Kremlin, then one gets a view of the Kremlin from the far side, with the church of Christ the Saviour, the Great Palace, the cathedrals, the Saviour Tower and the buildings inside the Kremlin.

Two days after the entry into the Kremlin, after countless official banquets and receptions, another event occurred and again it is depicted in the panorama. Men in medieval herald's attire announced the day of the sacred coronation, proclaiming with loud voices the text of Nicholas II's speech to the people and distributing copies as a souvenir on their way through the city.

The coronation itself took place on 14 May 1896 in the Assumption Cathedral. A special dais was built opposite the altar under a canopy. It was covered with a carpet, as was the whole route that the monarch took from the steps of the Palace of Facets. Three

thrones were placed on the dais, one for the tsar in the middle and two for the tsarinas on either side.

Stands were built for the public throughout the square. Inside the cathedral places were reserved for the highest dignitaries; next to the dais and the altar were the clergy. The procession from the palace apartments in the Kremlin to the Assumption Cathedral began at half-past nine in the morning. It was even more magnificent than the tsar's entry into the Kremlin. The horse guards, a mass of courtiers, senators and ministers, the members of the Council of State, the delegates from the cities and the *zemstvos* (provincial governments) – it was like a river of uniforms gleaming in the sunlight.

The first to enter the cathedral was the tsar's mother; she went and stood before her throne. In the words of Grand Duke Gavriil Konstantinovich: 'Their Majesties entered the cathedral after her. His Majesty the Tsar wore the uniform of the Transfiguration. Her Majesty the Tsarina wore a Russian silver brocade robe. They also went and stood before the throne. The coronation service began in an exceptionally festive atmosphere. The Assumption Cathedral, that had witnessed some centuries of Russian history, and where all the Romanov tsars had been crowned, the great group of clergy in splendid vestments with the metropolitan bishops

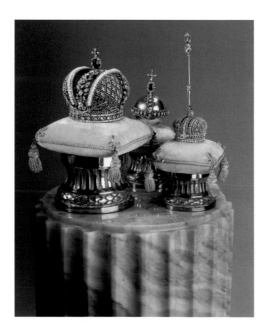

MINIATURE COPY OF THE SYMBOLS OF IMPERIAL POWER, *1899–1900*
Masters Yuli Alexandrovich Rappoport and August Vilhelm Holmström, Fabergé
gold, silver, platinum, diamonds, spinel, pearls, sapphires, velvet, pink quartzite

CAT. NR. 129

at their head, the beautiful singing – the whole scene gave the ceremony a profoundly mystical character.'

The service was conducted by the three metropolitan bishops, those of Moscow, St Petersburg and Kiev. After saying the prayers that had been chosen for the coronation ritual 'he [Nicholas] ordered to present him with his crown'. After accepting it from the hands of the metropolitan bishop of St Petersburg and 'standing in his tsar's robes before his crown, he placed it on his head.' Thereupon he was given the symbols of his rule – the mace and sceptre.

After reading the special prayers for the coronation and hearing the responses of the metropolitan bishop spoken in the name of the Russian people, the tsar went to the throne on the altar to be anointed and to receive the sacrament.

As he was climbing the steps to the altar, the massive chain of the order of Saint Andrew slid off his shoulder, something those attending saw as a bad omen. After a moment's hesitation, those close to the Tsar who noticed the incident, behaved as though nothing odd had happened. Nobody said a word about the incident for fear of spreading superstitious gossip. On leaving the altar as consecrated tsar, Nicholas took off his crown, touched the head of the kneeling tsarina with it, put it back on his head and set the smaller crown on her head.

'The ceremony was conducted in a very warm and human atmosphere', wrote the tsar's sister. 'Aliki kneeled before Niki. I will never forget how attentively he placed the crown on her head and how tenderly he kissed her and helped her to her feet.'

The concluding moment of the ceremony in the stately interior of the Assumption

SAMOVAR WITH MONOGRAM, *1896*
Erven Vasili Stepanovich Batashov
Samovar Factory, Tula
copper, hammering, gilt, engraving,
carving, ivor

CAT. NR. 154

Cathedral is depicted in Pyasetsky's panorama and in a painting by the Danish artist Laurits Tuxen, that is also in the exhibition. The magnificent procession then made its way to the Archangel and Annunciation Cathedrals and after greeting the people from the steps of the Palace of Facets, the tsar and tsarina proceeded to the Kremlin Palace.

From the diary of Nicholas II: '14 May. Tuesday. A great and solemn, but, in a spiritual sense, heavy day for Alix, mamma and me. From eight in the morning we were up and about; and our procession only started moving at half-past nine. Fortunately the weather was perfect: the steps of the palace offered a glorious view. It all happened in the cathedral

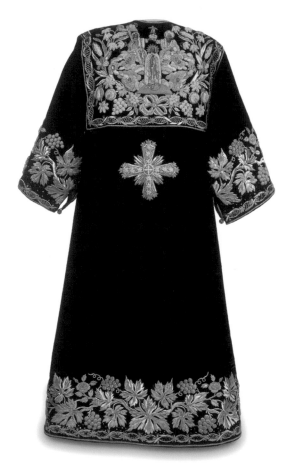

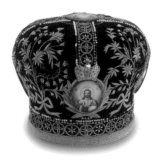

CAT. NR. 185 (left)
DEACON'S VESTMENTS, *end 19th century*
Russia, Moscow
velvet, silk, metal, wire, hammered wire,
gold thread, sequins, river pearls

CAT. NR. 186 (above)
MITRE, *2nd half 19th century*
Russia
velvet, silk, metal, enamel, wire, sequins,
gold thread, cultured pearls, embroidery

of the Assumption. Although it felt like a dream, I shall never forget it all my life!!! We returned once more at half-past one. At three o'clock our procession set off again in the same order for the Palace of Facets, where we sat down at the great table. Everything went according to plan and by four o'clock it was over. With my soul filled with gratitude to God, I was able to take a complete rest.'

The impressions of this day are also recorded in the memoirs of Grand Duke Alexander Mikhailovich: 'Perfect days of spring, a historic city entirely decorated with flags, the sound of bells from sixteen hundred bell towers, the huge crowds shouting "hurrah", the young tsarina wearing her crown, radiant with beauty, leading dignitaries from all the European nations in golden carriages. No strict ceremonial could have stirred the masses to greater enthusiasm than the sight of this spectacle.'

14 May was the day of the official confirmation of Nicholas II as tsar of Russia. There were to be congratulations, receptions, festivities, balls and popular festivities. Many of these ceremonies were held in the state rooms of the Kremlin Palace. Pyasetsky must have painted these rooms before these events took place, because although he wasn't invited, he could hardly have omitted them in his panorama. The rooms of the Terem Palace, that linked up with those of the Kremlin – the Vladimir, Catherine, Alexander and Saint George's Halls – were all depicted beforehand.

From the diary of Nicholas II: '15 May. Wednesday. At half-past eleven I received the congratulations of the clergy, the representatives of the highest public bodies, the nobility, the *zemstvos* and the cities. Unexpectedly however the congratulations ended at breakfast time, two hours earlier than planned.' This reception took place in the Throne Room, that is also depicted in the panorama.

One special feature of the coronation was the exceptionally colourful illuminations in Moscow, powered for the first time with electricity. They were lit on 9 May in the evening after Nicholas II's entry into Moscow, when the tsar and his spouse were in the Kremlin.

'At nine o'clock we went out onto the highest balcony', Nicholas continues in his diary, 'and there Alix lit the electrical illuminations of the bell tower of Ivan the Great, after which the towers and walls of the Kremlin, the opposite bank and the neighbourhood on the far side of the River Moskva were lit up in turn.' In the official description of the coronation we read: 'Her Imperial Highness the Tsarina Alexandra Fyodorovna was presented with a bouquet and when Her Highness was so good as to accept it, it lit up all by itself with a large number of little electric lamps; and at the same moment, due to an unusual system of electric wires, as if someone had waved a magic wand, the different coloured lamps began to shine from the towers and the bell tower of Ivan, after which the other lamps also lit up on the towers and

BULBOUS CENSER IN 17TH-CENTURY STYLE, 1900–1910
A.N. Sokolov Studio, St Petersburg
silver, gilt, casting, filigree, incense grains

CAT. NR. 147

Diner
25 Mai 1896.

Potage Tortue clair.
Crème de Concombres.
Bouchées aux Crevettes-Canelons.
Sterlet du Don au vin de Champagne.
Selle de Pré Salé aux légumes permeaux.
Jeunes Poulets truffés à la Périgord.
Soufflé froid de foie gras.
Punch.
Faisans de Bohême à la broche.
Salade.
Petits Pois à l'Anglaise.
Ananas à l'Orientale.
Timbale Cardinal aux fraises.
Dessert.

CAT. NR. 53 (top)
MENU OF THE BANQUET AT THE MOSCOW KREMLIN FOR
THE CORONATION OF NICHOLAS II ON 25 MAY 1896, *1896*
Earnest Karlovich Lipgart (*1847–1932*)
colour lithograph

CAT. NR. 54 (right page)
MENU OF THE SUPPER GIVEN BY MOSCOW'S
GOVERNOR-GENERAL GRAND DUKE
SERGEI ALEXANDROVICH ON 20 MAY 1896, *1896*
Viktor Michailovich Vasnetsov (*1848–1926*)
colour lithograph

walls. The sight from the terrace across to the extravagantly illuminated opposite bank of the Moskva was quite splendid.'

The multicoloured illuminations, the electric cascades beside the walls of the Kremlin, that lit up the Moscow sky, the projectors – all this was a great technical novelty. An enormous amount of money was spent designing these illuminations. Famous

Russian engineers, architects and artists were involved in the spectacle. It was commented on not only by the popular press but also in technical journals throughout the country.

Most of the members of the tsar's family and the foreign visitors then went off for a walk through Moscow which, according to the memoirs of Grand Duchess Olga Alexandrovna, was transformed into a fairy-tale city. Vladimir Nemirovich-Danchenko, coronation correspondent for the journal *Niva*, observed the lights with his colleagues from the roof of the Rumyantsev museum. 'We held our breath, literally afraid we might disturb this astonishing *fata morgana* by gasping; all we could do was stand and stare, enchanted by the beauty for which no description was adequate, alternating our whispers with suppressed shouts.'

Pyasetsky surpassed himself in depicting the beauty of the illuminations in marvellous fashion. The scene with the night-time festivities in Moscow night was the most imposing part of the panorama, with its battery of colour effects, taking into account how the spectators must have seen it from a distance.

The grand finale of the coronation was over. Now the most tragic of the feast days was approaching, bringing with it a disaster that would drive out all the other impressions and cast a shadow over the whole of Nicholas's reign. On 18 May a popular festival had been planned on the Khodynka Field with a distribution of coronation presents: sweetmeats and enamel mugs with the arms of the city and the monogram of the Tsar. The Khodynka Field, situated on what was then the edge of Moscow opposite the Peter Palace, was normally used as an exercise ter-

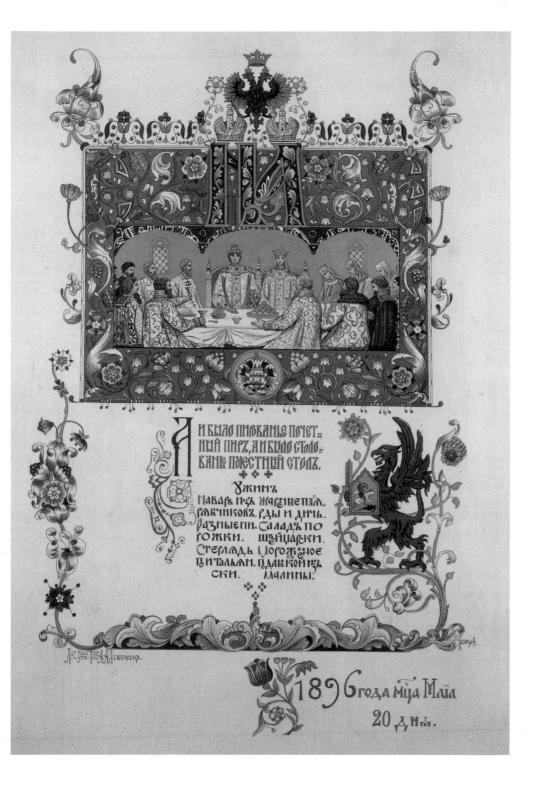

rain for artillery and sappers. The trenches and potholes dug there by engineers, had not been properly filled in, and the police force posted there to keep the peace was inadequate to keep back such a large crowd. People had started streaming into the field before nightfall, and by morning they numbered about half a million. The authorities took practically no notice of this situation, even though there was still time to take measures before daylight.

PORTRAIT OF TSAR
NICHOLAS II, *1890's*
Sergei Lvovich and
Lev Sergeyevich Levitski
photogravure

CAT. NR. 88

The accident occurred at around six o'clock. Word had spread among the crowd that there were not enough presents, and everyone of course wanted a souvenir of the occasion. When day dawned and revealed the pyramids of mugs piled high on special wooden platforms, '[the crowd] rushed forward as one man, as desperately as though they were fleeing a fire', says one person who witnessed the event. 'The rows of people behind pressed down on those in front and anyone who fell over was trampled on; People didn't even realize that they were walking over living bodies, they felt more like rocks or wooden beams.'

'The weather was excellent', wrote the journalist P. Shostakovsky. 'The morning was calm, without any wind. There wasn't a breath of fresh air, and in the crush it was harder and harder to breathe. Sweat poured

down over the ashen faces of the crowd, as though they were shedding tears. And the half-million strong packed mass of bodies was driven with all its unimaginable weight towards the buffets. They fell in their thousands in the trenches, on top of the heads of those already standing there. Behind them even more people fell, until the ditch was filled to the brim with bodies. And people walked over them. They couldn't help themselves, it was impossible to stop.' The crowd went down, trampled on and crushed. The official figure states that there were 2690 victims in the Khodynka Field alone, including 1389 deaths.

'Up till then, thank God, everything had run smoothly, but today a great tragedy took place', Nicholas II wrote in his diary of 18 May. 'The crowd that had waited overnight in the Khodynka Field to be given food and mugs, fell against an earthwork and people there were terribly crushed, so that – it is dreadful to confess – about 1300 people were trampled on!!! I heard the news at half-past ten.'

Straightway people started moving the dead and wounded from the field, to erase all traces of the catastrophe and to prevent any delay to the arrival of the Tsar, planned for 2 o'clock. Many people witnessed the spectacle of the slow carts taking away the dead, hastily covered with mats and canvas. Among the Muscovites who observed this appalling

scene were some members of the tsar's family. Grand Duchess Olga Alexandrovna wrote, 'The Moscow authorities dealt with the matter incompetently, and the same goes for the court officials. Our coaches were ordered too early. It was a marvellous morning. I remember how happy we felt as we rode through the gates of the city, and how short-lived that happiness was.' A line of carts came towards them. They were covered with pieces of canvas, with many arms sticking out. 'At first I thought they were people waving at us. Suddenly my heart stopped. I began to feel sick, but I continued to stare at the carts. They were transporting corpses. The drama had broken the spirit of the Muscovites.'

It was a terrible catastrophe that shook Moscow to its foundations. The reputation of the Tsar was badly damaged. After that, he was nicknamed 'Nicholas the Bloody', while the governor-general Grand Duke Sergei Alexandrovich became known as the 'Duke of Khodynka'. The name 'Khodynka' has entered the Russian language as a byword for all popular occasions where accidents occurred. Equally importantly, Khodynka was a harbinger for the new reign, the prelude to future disasters.

Watching the carts with dead bodies rolling forwards, Sergei Witte, the minister of Finance, wrote that he was mainly tormented by two questions: 'Will they manage to get all those still alive to the hospitals on time and transport the corpses to some

spot where they won't be seen by the rest of the people, who are still celebrating, or by his Majesty, all his foreign guests and the whole entourage of more than a thousand?' And 'shouldn't the Tsar issue a decree now to cancel the whole festivities and have a day of mourning for the tragedy, ordering a solemn mass to be celebrated instead of the songs and concerts?'

PORTRAIT OF GRAND DUKE ALEXANDER MICHAILOVICH AS A YOUNG MAN, 1882
Maria Vasilyevna Etlinger (Eristova) (?–1934)
watercolour, colour and graphite pencil, pastel chalk, lacquer on paper

CAT. NR. 38

In the Tsar's family discussion about whether the festivities should be cancelled raged. Alexander Izvolsky, who later became foreign minister, testified that the tsar and tsarina were deeply distressed by the tragedy and wanted to call off the festivities. Grand Duke Alexander Mikhailovich and his brothers demanded the immediate sacking of the governor-general, Grand Duke Sergei Alexandrovich and the cancellation of any further coronation festivities.

Grand Duke Nikolai Mikhailovich attempted to persuade the young Tsar that, 'the blood of the five thousand men, women and children will be a permanent blot on your reign. You cannot resurrect the dead, but you can show your concern for their families. Do not give your enemies any reason to say that the young tsar was dancing while his deceased subjects are being taken to the

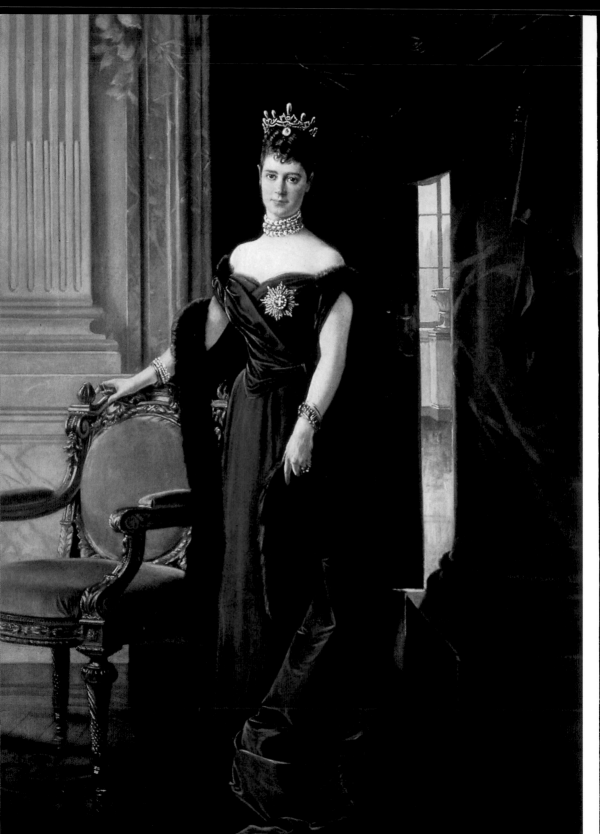

mortuary.' The mother of the tsar, the Tsarina Maria Fyodorovna, also belonged to this group.

The older generation of Grand Dukes, the brothers of Sergei Alexandrovich, supported the governor-general. He felt that he bore no blame for the disaster and that there could be no question either of him being sacked or of any mourning. He did not visit the scene of the disaster, displayed no sympathy for the families of the victims and denied that there was any need to investigate the cause of the tragedy. In his view, the event was an 'accident', the victims 'unexpected', and the festivities should therefore not be disturbed.

Nicholas decided not to alter the timetable for the coronation celebrations. At 2 o'clock on 18 May the tsar and tsarina were present in the Khodynka Field as planned. From the tsar's diary: 'At half-past twelve we had breakfast and Alix and I left for Khodynka to attend that mournful "festival". There was nothing to be seen: we gazed down from a pavilion on a colossal crowd round a platform where all the time musicians were playing hymns and the National Anthem.'

The *Niva* correspondent who attended the festivities, Vladimir Nemirovich-Danchenko wrote about the theatre pavilion set up on the field, the choirs, the acts of the clown Durov and the fashionable public on the stands, but he also mentioned that the

corpses that had not yet been removed still lay there in tents at the edge of the field: 'It is true there were few people, you could walk freely around the field. The atmosphere was hardly cheerful. Next to the fairground booths and the gypsy choirs lay a pile of dead bodies. The contrast was remarkable and felt like a nightmare.'

On the evening of the same day Nicholas and Alexandra were in a sad frame of mind, but the tsarina still went to the ball of the French ambassador, De Montebello, the tears still fresh on her face. The political purpose of this event – to strengthen the Franco-Russian alliance – meant nothing to the vast mass of people. In the two days after the catastrophe the tsar and tsarina did however visit the wounded in the hospitals and on the orders of the Tsar a funeral meal was offered to his loyal subjects, in the court chapel. All the families who had lost a loved one received 1000 roubles each and money was provided from the treasury for the funerals. No gift however could erase the terrible impressions of that day. It felt like a bad omen for the new reign and it remained engraved in everyone's memory.

Of course the catastrophe in the Khodynka Field is not depicted in Pyasetsky's panorama of the coronation celebrations. A people's party held in daytime was however sketched, showing the pavilion of the tsar and a festive crowd with balloons floating skywards. Chronologically, the picturesque furnishing of the halls of the Assembly of the Moscow Nobility is depicted next, where a great ball was held on 21 May. The panorama ends with the final event of the coronation, the military parade on 26 May on the same Khodynka Field. Nicholas II was delighted; to all appearances the coronation

PORTRAIT OF TSARINA MARIA FYODOROVNA, *1880's*
AFTER THE ORIGINAL BY F. FLAMENG
Unknown lithographer *(late 19th/early 20th century)*
lithograph, colour print

CAT. NR. 52

celebrations had closed in the same festive atmosphere as they had begun.

In the tsar's response to all the official events of the ceremony one is struck by his deep conviction that the tasks of a monarch were a heavy burden sent him by God and that he was doomed to bear them all his life. After the noisy festivities he travelled with his family to Grand Duke Sergei Alexandrovich's estate at Ilyinskoe near Moscow. 'An indescribable happiness to have arrived at this lovely peaceful spot!', wrote Nicholas II. 'And the greatest consolation is that all the festivities and ceremonies are over and that I can now live quietly and peacefully for myself.' He couldn't have known that these peaceful days were the beginning of an arduous road full of tribulations.

The liberally-inclined Prince Sergei Mikhailovich Volkonsky (grand son of the Decabrist revolutionary Sergei Grigoryevich Volkonsky) wrote in his memoirs, 'During the coronation of Nicholas II, I remember talking to someone who shared my feeling that this would be the last. In the midst of this carefree climax I thought, we have to be vigilant, because what if the people have had enough of shouting "hurrah" and what will they do when they no longer get any pleasure out of a "piece of theatre"?' The darkest times were yet to come, because the coronation was only the beginning of the most tragic period in the history of Russia.

PRESENTATION BY TSAR NICHOLAS II OF THE COLOURS TO THE 145ST INFANTRY REGIMENT OF NOVOCHERKASSK, *1900*
Narkiz Nikolayevich Bunin (*1856–1912*)
oil on canvas

CAT. NR. 04

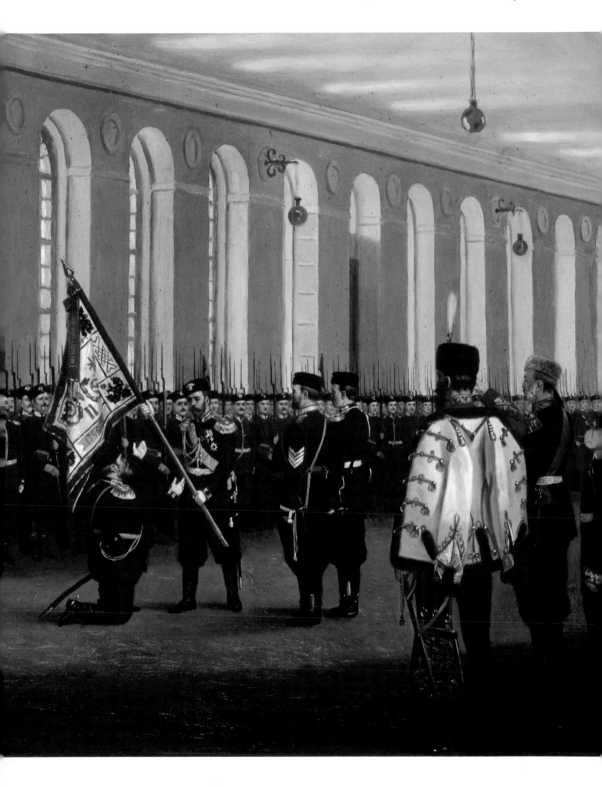

Augusta Pobedinskaja

Tsarevich Alexei

the heir to the throne

Portrait of the heir to the throne
Tsarevich Alexei Nikolaievich with
sketches of the portraits of his older
sisters the Grand Duchesses Olga,
Tatiana, Maria and Anastasia, 1911
Mikhail Viktorovich Rundaltsov
(1871–1935)
dry-point etching

CAT. NR. 47

On 4 July 1904 a great event occurred in the family of the Tsar – the birth of their long-awaited son, the successor to the Russian throne. The public was informed of the joyful news by a 301-gun salute from the cannons of the Peter and Paul Fortress. The birthday of the successor to the throne was a great festival, not just for the tsar and his family, but for the whole population. People went out onto the street, prayers of thanksgiving were offered in the churches, bells rang out and at night the city was illuminated by bonfires.

Traditionally the succession in Russia was based on the male line, but this was broken by Peter the Great, who published a *ukase* that the heir was to be appointed only by the tsar. After his death this led to a series of palace coups, resulting in the accession of Catherine I (1725-1727), Anna Ioannovna (1730-1740), Elisabeth Petrovna (1741-1761) and Catherine the Great (1762-1796). Finally in 1797 Tsar Paul I issued a *ukase* on the question, declaring that the succession was to be based on seniority and again only via the male line. After that the law was never breached.

Nicholas II had had four daughters in a row (Olga, Tatiana, Maria and Anastasia). As long as no male child was born, his younger brother Mikhail Alexandrovich was thus the official heir. For this reason the birth of a son, the fifth child, was an exceptionally important occurrence for Nicholas and his wife.

In his Diary for 30 July the tsar wrote: 'An unforgettable and great day, on which we received so evident a sign of God's love. At a quarter past one in the afternoon Alix had a son, who was named Alexei during prayers. Everything proceeded at a remarkable pace. As always I was with Mamma in the morning [...] then I joined Alix to eat [...] Half an hour

later the happy event took place. No words are adequate to thank God for the consolation he has bestowed on us in this year of difficult tribulations [...]'.

The name of the heir to the throne was not chosen by chance. It was also that of one of the first members of the Romanov dynasty, Tsar Alexei Mikhailovich (1645-1676), later known as 'the unifier of Russia'. Nicholas told an acquaintance, 'The tsarina and I have decided to call the heir Alexei; it's time we broke with the series of Alexanders and Nicholases.'

The happiness of Nicholas and Alexandra knew no bounds. The boy was healthy and a delight and soon became the family's darling. 'He is an amazingly calm baby, he almost never cries', the happy father wrote in his Diary. A wet nurse was invited, but his mother never left the boy's side. The tsarina's intimate friend Anna Vyrubova describes little Alexei, 'I saw the tsarevich in the tsarina's arms. How beautiful and contented he was. With his golden locks, blue eyes and a wise expression on his face that was unusual for a child of his age.'

His christening was fixed for 11 August and was celebrated in the Alexander Palace where he was born. According to the tradition of the orthodox church his parents were not present. The most important godfather was the tsar's uncle Alexei Alexandrovich, while dowager-tsarina Maria Fyodorovna

PORTRAIT OF THE DANISH KING
CHRISTIAN IX HOLDING TSAREVICH
ALEXEI NIKOLAYEVICH, 1904
Carl Sonne
photo

CAT. NR. 66

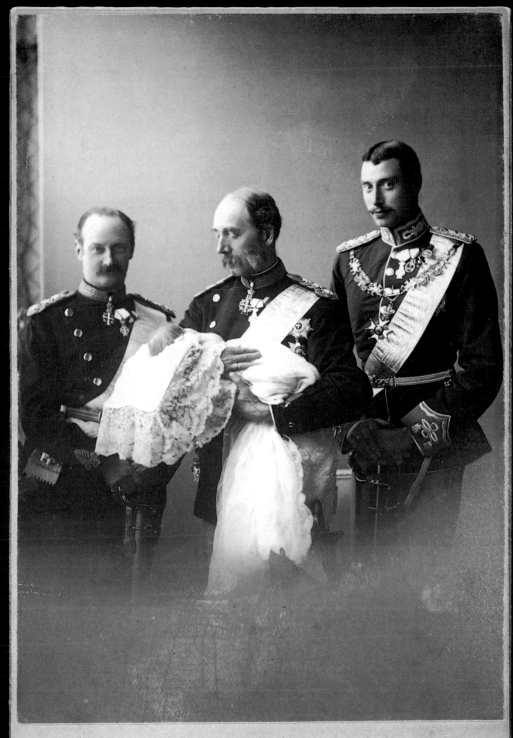

Carl Sonne.
HOFFOTOGRAF.

Rjøbenðavn.

was the main godmother. After the ritual the tsar presented his tiny son with the highest Russian order, the gold chain of Saint Andrew. The population of St Petersburg heard the news of the event via a twenty-one gun salute from the fortress of Peter and Paul, those in Moscow from the Secret Tower of the Kremlin. After the christening the diplomats who came to congratulate the family were invited to breakfast. A manifesto was also issued on the occasion, offering favours to the tsar's subjects: amnesties or shorter sentences for prisoners, the abolition of corporal punishments, aid to orphans and the like.

But family's happiness was short-lived. Less than a month later the delightful boy baby whom everyone had welcomed with

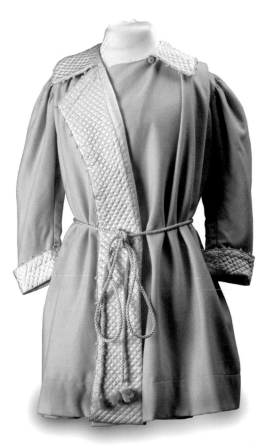

CAT. NR. 08 (top)
CHURCH PARADE OF THE
FINNISH REGIMENT OF GUARDS, *1906*
Boris Michailovich Kustodiev (*1878–1927*)
oil on canvas

CAT. NR. 166 (left)
DRESSING GOWN OF TSAREVICH
ALEXEI NIKOLAYEVICH, *1900–1910*
Russia, St. Petersburg
cashmere, silk

such joy, gave his parents the bitterest possible disappointment. Little Alexei's navel suddenly started to bleed and it was beyond the power of the famous doctors who were called in to stop it. It was not until the second day that they managed to staunch the flow. From that

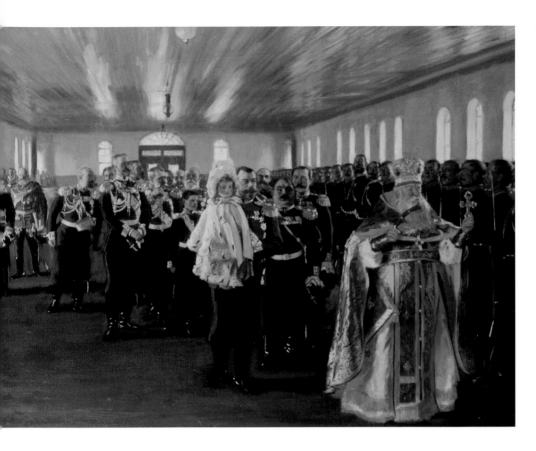

moment on the health of the heir to the throne was the foremost problem for Nicholas and Alexandra both as parents and as heads of state. The family's anxiety was made still greater by the fact haemophilia was hereditary in the dynasty of Hesse-Darmstadt. The disease was incurable and some members of this family had suffered from it. Queen Victoria had passed it on to her daughters Beatrice and Alice (Alexandra's mother). Frederick who was Alice's son and Alexandra's brother, had died of it at the age of three.

The strictest measures were taken to deal with Alexei's disease, and to ensure his health. Its nature was kept secret, even being withheld from the inner circle of the court. A short while after his birth the tsar and

his family moved from Peterhof to the Alexander Palace in Tsarskoe Selo. There they were able to lead a fairly peaceful and secluded life, especially as Alexandra did not care for the official receptions in the Winter Palace. Nicholas was proud of his son and showed him to everyone who visited Tsarskoe Selo. In his Diary for 4 August 1904 he wrote, 'It was a very busy morning. The commandants of the guard units arrived first thing, twelve of them, to thank me for having little Alexei enlisted in their ranks.'

The tradition of members of the tsar's family being as it were 'adopted' by heads of guard divisions had a long history in tsarist Russia. For an heir to the throne to be made commander of a regiment was an exceptional

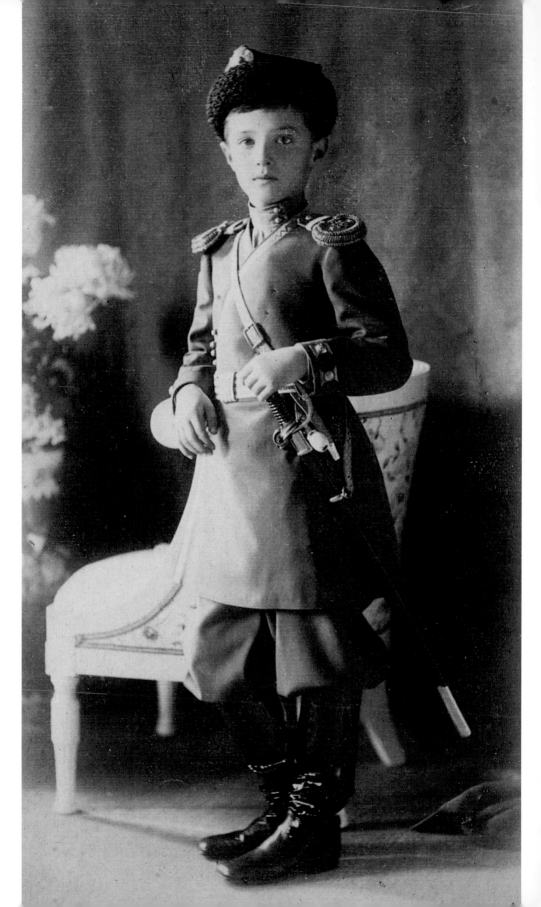

honour. Only a few days after the birth of the tsarevich, the *hetman* or commander of the Astrakhan regiment of the Cossacks received a telegram from the tsar: 'It is with great joy that I instruct you to inform the Cossacks of the Astrakhan unit that the Heir to the Throne Tsarevich Alexei Nikolaevich is appointed *hetman* of all the Cossack regiments. Nicholas .'

When the heir to the throne was a little older, a start was made on introducing him to the regiments that he was to command. In this context it is worth quoting the reminiscences of General Krasnov, who was there when the tsarevich was presented to the *Astrakhan* regiment. 'His Highness took his successor by the hand and went slowly with him past the front line of the Cossacks [...] And when His Highness walked on [...], the Cossacks wept and waved their swords in their rough calloused hands.'

When the tsarevich was a year and a half old, he was introduced to the Finnish regiment. Nicholas II's diary entry for 12 December 1905 reads: 'At half past ten a church parade was held in the *Exerzierhaus*: for the first company of the Page corps, the Finnish regiment and the platoon of the Volyn regiment. Alexei was present and he conducted himself well. After the clergy had sprinkled with troops with holy water I took him by the arm and carried him along the front rank. The first time that the Finns and their commander saw each other.' The occasion was depicted by the artist Boris Kustodiev in a

PORTRAIT OF TSAREVICH
ALEXEI NIKOLAYEVICH, *1910– 1912*
Boissonas and Eggler Studio
photo

CAT. NR. 91

painting of 1906, *The solemn parade of the Guard of the Finnish regiment.*

The tsarevich was too young then to understand anything of the significance of the occasion. Pierre Gillard who later became his tutor, and was then French teacher to the daughters of the tsar, describes his first meeting: '[...] In February 1906 I met the heir to the throne for the first time; he was one and a half years old [...]. I had just finished giving Olga Nikolaevna her lesson, when the tsarina came in with him in her arms. She came to meet us with the visible intention of showing us her son, whom I hadn't seen before. His mother's joy that her deepest wish had finally been granted was boundless. You felt that she was quite radiant with happiness and pride about her beautiful child. And the heir really was the most charming child you could imagine, with lovely blond curls, large pale blue eyes and long arched eyebrows! His complexion was that of a healthy boy, fresh and ruddy, and you could see how his rounded cheeks were covered with dimples when he smiled. When I approached him, he gave me solemn frightened look and only streched out his chubby little arm toward me with some reluctance.'

The tsar soon started taking his son to inspections and manoeuvres of army units to show him the role and power of an army for the survival of a state. Many regiments and private individuals gave the little boy presents. A delegation of Siberian Cossacks for example brought him a miniature Cossack battle outfit, with rifle, sword, lance and cartridge box. Workers from the Perm metal forging factories made a model of a cannon. Other sorts of present were also made for him. From one of the factories in the Ural region he was given a collection of miniature

PRINTING PRESS, 1904—1917
steel, wood, lead, velvet,
lacquer, polishing

CAT. NR. 163

farm tools and the pupils of the trade school in Odessa gave him a set of fitters' tools. One of the most original presents can be seen in this exhibition – a working model of a printing press, given to him by the inmates of a Russian jail. One of the most remarkable ones was the electric train brought by the president of France.

When he was a little older, the tsarevich was provided with a tutor. This was the retired boatswain of the Imperial yacht 'Standard', Andrei Derevenko, who accompanied him everywhere. Except for his sisters however, he had no children of his own age to play with. Only the two sons of Derevenko and the son of the doctor Botkin were allowed to play and have fun with him. In general only a limited circle of people had access to the tsar's family. The only place in Tsarskoe Selo where the family could go for a walk was the royal park.

Alexei grew up as a lively, energetic and even naughty young boy, but the adults of the family had to keep an eye on him all the time. They did all they could to protect the boy against any possible traumas. He loved working with his father in the park. They sawed down old trees and planted new ones, swept the snow away in the winter and built snowmen. The family spent the summer in the Crimea in the deep south of the country. There they went for long walks along the coast or in the mountains or they sailed in a boat or yacht.

Despite every precaution however, it simply wasn't possible to protect the tsarevich from small accidents. In his reminiscences Vladimir Voyeikov wrote, 'When he was three, tsarevich Alexei suffered a cut when he was playing in the park and he started bleeding. The family's principal surgeon was summoned at once, and he applied every known method to staunch the blood, but to no avail. The tsarina fainted [...]. His Majesty aged ten years in a single night.' The suffering of the little boy and his parents knew no bounds. Olga Alexandrovna, Nicholas II's sister also wrote about the incident, 'The poor little boy lay there in excruciating pain, with black rings under his eyes, contorted with suffering and with a dreadfully swollen leg. There was simply nothing the doctors could do to help. They looked even more frightened than we did [...]. Hours passed, and they gave up hope. Then Aliki sent someone to St Petersburg to

PORTRAIT OF GRIGORI RASPUTIN, 1914
Yelena Nikandrovna Klokacheva
(1871–after 1915)
colour pencil, pastel chalk on card

CAT. NR. 35

HERMITAGE✦AMSTERDAM

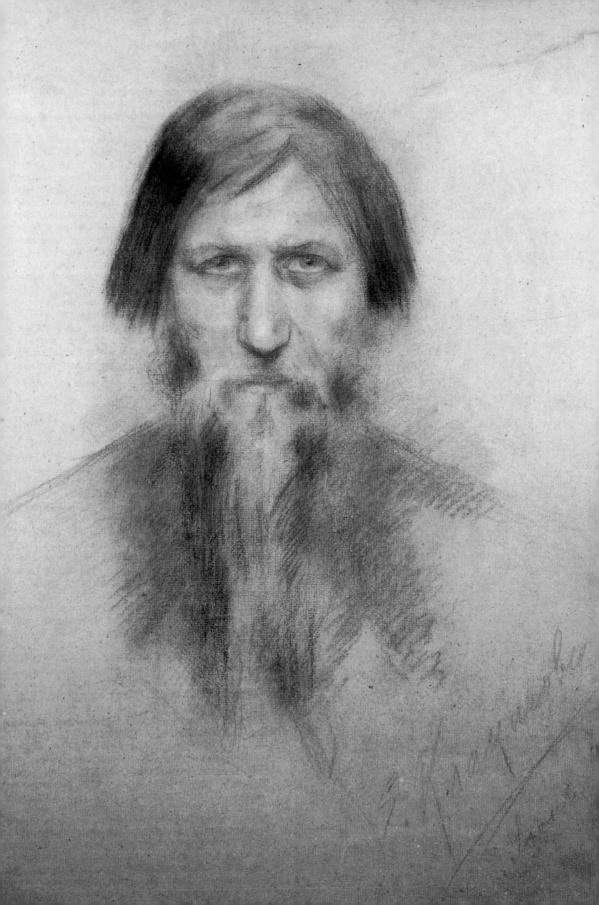

get Rasputin to come. He arrived in the palace around midnight or later still [...]. In the morning Aliki called me to come to Alexei's bedroom. I just couldn't believe my eyes. Not only was the boy alive; he was in good health.'

This was not the only instance, when doctors' efforts had proved in vain, that Alexandra Fyodorovna sought her salvation with people with paranormal gifts, quack doctors and 'wise old men'. She had ceased to have any faith in official medicine. Grigori Rasputin was recommended to her for the first time in 1907. He came late in the evening, saw how the boy and his mother were suffering and remained seated by Alexei's bed, saying prayers. In the morning the child had recovered. From then on the family began to believe in the miraculous power of the 'wise old man' and appealed to him for help on many occasions.

The first time Rasputin is mentioned as having been at the court of the tsar was 1905. 'We had the good fortune', Nicholas wrote in his Diary, to meet the man of God Grigori

from the province of Tobolsk'. Despite Russian society's growing dislike of Rasputin, the tsarina 'accepted him unconditionally'; for her it was enough that he knew how to relieve her son's suffering.

The French ambassador Maurice Paléologue gives us a sharp character sketch of the man. 'His gaze was both fierce and endearing, naive and cunning, distant and severe. During a serious discussion it was as though his pupils radiated magnetic waves [...]'.

The most serious occurrence took place in the Belovezhski forest (now on the border of White Russia and Poland) in 1912. This great expanse of forest was one of the tsar's favourite hunting grounds and he often went there with his entourage. The woods were famous for their wealth of game such as roe deer, bison and aurochs. The boatswain Derevenko describes the visit of the tsarevich whom Nicholas had brought with him in his diaries. They 'sailed in rowing boats, they went into the forest in motor boats and saw twenty aurochs and a wild boar, they looked for mushrooms, built a campfire in the garden, cooked the mushrooms'. On 6 and 7 September the note is by someone else: 'In

CAT. NR. 116 (left)
PRESENTATION DISH COMMEMORATING
THE TERCENTENARY OF THE HOUSE OF
ROMANOV, PRESENTED BY THE PEOPLE
OF THE CITY OF VLADIMIR, 1913
Studio of Nikolai Fyodorovich,
Strulev, Moscow
wood, silver, almandites, chrysolites; enamel,
casting, chasing, painting on enamel

CAT. NR. 46 (right)
PORTRAIT OF TSARINA
ALEXANDRA FYODOROVNA, 1905
Michail Viktorovich Rundaltsov (1871–1935)
etching

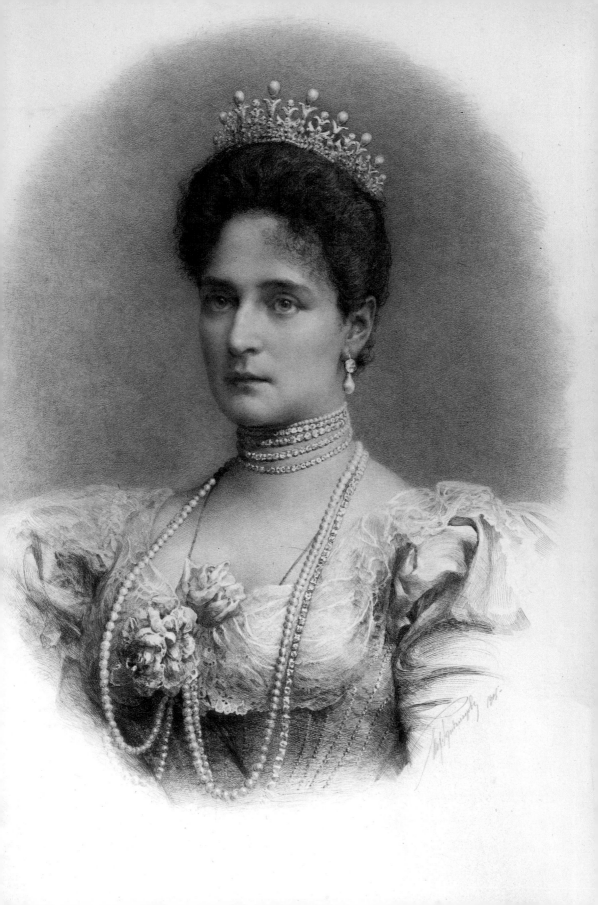

the morning we stayed home, his leg was hurting and a compress was put on it, we played cards.' And the next day: 'The heir to the throne is still not well. We didn't go out for a walk, we played draughts and did some drawing.'

This new bout of Alexei's illness began when, without thinking, he jumped from a boat and bumped his leg. The internal bleeding was impossible to stop and his condition got steadily worse. Once again the most famous doctors were summoned – the pediatricians Ostrogorski and Rauchfuss and the surgeon Fyodorov. But they were powerless to do anything. The bleeding in his groin caused him unbearable pain, his temperature rose to 40 degrees centigrade, sometimes he lost consciousness. His condition was so bad that everyone was prepared for the worst.

Alexandra did not leave his side for a minute. In a state of total desperation she ordered Anna Vyrubova to send a telegram to Rasputin, who at that moment was in his own homeland in Siberia. Next day they got his answer, 'God has seen your tears and heard your prayers. Don't be sad, the little boy is not going to die. Don't let the doctors frighten him.' The following day the bleeding stopped and the boy was able to sleep again. Vyrubova wrote,'The boy lay there exhausted, completely worn out by the sickness, but he was alive.'

Only once Alexei had recovered a bit, did Nicholas II write his mother a letter, telling her that 'the days from 6 to 10 October were the worst. The unhappy little fellow suffered agonies. The pains produced spasms that

from left to right:
CAT. NR. 158
WHITE PLUSH BEAR, *1900—1910*
wool plush, cloth, glass
J.P.

CAT. NR. 157
'MONKEY', *late 19th century*
fabric, plush, mastic; cloth (shirt and frock)
featuring a floral motif

CAT. NR. 159
PLUSH DOG, *1900—1910*
wool plush, cloth, glass
J.P.

CAT. NR. 160
PLUSH CAT, *1900—1910*
wool plush, cloth, glass, metal

recurred every quarter of an hour. He was delirious [...]. He could hardly sleep, or even cry; all he could do was groan and say, "Lord have mercy on me".'

Pierre Gillard, who kept a diary during the tsarevich's last years wrote of his frequent bouts of sickness. It goes without saying that the fact that he was often ill prevented Alexei from studying seriously. It was not until 1913 that his education was at all systematic. His oldest teacher was Pyotr Petrov, who taught him Russian; Stanley Gibbs taught him English and Pierre Gillard was his French tutor. The tsarina herself took on the task of instilling in him the principles of statecraft and the Ten Commandments and she often also attended other lessons. In the Alexander Palace, where the family of the tsar lived a great deal of the year, Alexei had two rooms – a bedroom and a classroom where he had his lessons. As Gillard said, 'with his great mental agility he would have been able to develop normally, if his sickness hadn't pre-

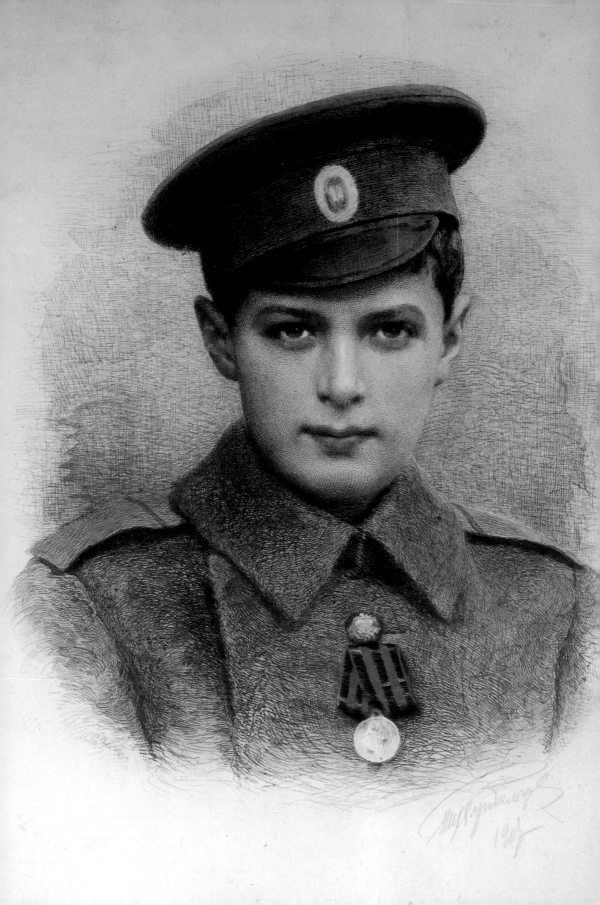

vented him. It meant that interruptions had to be allowed for, which made his education an extremely hard task, despite his natural abilities.'

Literally everyone who met the family of the tsar over the years, spoke of the charm and wisdom of the tsarevich. One of the tsar's equerries, who had observed Alexei at different periods and in different situations wrote afterwards, 'It was infinitely sad to see a boy who was attractive in every respect and who was remarkable for his great talents, enormous memory, physical beauty and a mental agility that was astonishing for his age, suffer from a chronic sickness that was usually provoked by some small piece of carelessness during play.'

In 1913 a major event was celebrated in Russia – the third centenary of the Romanov dynasty. Like the coronation, the closing festivities were held in Moscow. The ritual was planned down to the minutest details. The tsar was supposed to enter the Kremlin by foot while the tsarina and tsarevich rode on in their coach. At the time Alexei had not yet completely recovered from a bout of his sickness and was unable to walk. He had to be held in someone's arms during the inspection of the regiments : 'the fragile little figure of the Tsarevich stood out against the hands of a burly Cossack. The thin little arm of the Tsarevich clung to his strong broad neck, the emaciated little face of the tsarevich was so pale as to be almost transparent, and his amazingly beautiful eyes were full of grief.'

PORTRAIT OF TSAREVICH
ALEXEI NIKOLAYEVICH, 1917
Michail Viktorovich Rundaltsov
(1871–1935)
etching, watercolour

CAT. NR. 49

The boy's health improved as he grew older, but nonetheless it was essential to keep an eye on him. Alexei had many toy soldiers that he loved playing with, especially when he couldn't move about. With Derevenko and his two sons he laid out ranks of soldiers for a parade, a campaign or a charge. Playing with them gave him lessons in the science of war and in history. Among the toys was a relief map of the Battle of Borodino, that he had been given by the chamberlain Sergei Khitrovo. Not only did it give a general depiction of the war with Napoleon (1812), it also showed many separate episodes of the battle and views of the surroundings, the road and the buildings of the village of Borodino.

At home the loyal friend of the mischievous and highly active Alexei was his sister the Grand Duchess Anastasia, who was considered a 'hopeless good-for-nothing'. The equerry Simeon Fabritski describes how Alexei raced around with the cabin boys when he was sailing on the sailing boat *Polyarnaya zvezda* ('Pole star'). Another contemporary describes an incident of 1913 in the Livadia Palace in the Crimea, when 'Alexei Nikolaevich was feeling relaxed and happy and played [...], with Kolya (Nikolai) Derevenko and made an incredible amount of noise, not sitting still in his chair for a moment before springing up again and diving under the table.'

'When he got the chance he enjoyed life, like any other happy, active boy. When he was in good health, it was as if the palace was reborn, he was like a ray of sunshine lighting up everything and everyone', wrote Pierre Gillard.

Gillard's note in his Diary gives us a very complete picture of the daily life of the heir to the throne. This is his entry for 7 January

1914: 'The compulsory lessons started at 10.20 — Russian, the Ten Commandments, algebra, French and English. Between the lessons A.N. walks in the park, goes sledging, plays and runs round.' The entry for 16 January reads, 'Between 11 and 12 in the morning he went walking. In the daytime he received a delegation of peasants from Ekaterinoslav [now Dnepropetrovsk], who gave him an icon. Walking and lessons. He doesn't feel well (pain in his right thigh-bone under the groin).' And another entry for 10 February reads, 'He got up at 8 after a good night's sleep [...]. Lessons. [...] He was in a mischievous mood and poured water over the chamberlain, on the floor, the white carpets and the walls.'

As the successor to the Russian throne Alexei Nikolaevich was expected to attend many official festivities, receptions and parades. Most of them involved religious festivals of those regiments that he was commander of or where he belonged to the staff. His father had taught him from an early age to understand the art of war. He was presented with an army uniform which a number of regiments had combined to make for him and he wore it all the time, as we can see from many photos. He often appeared in a sailor suit and cap with the name of the vessel 'Standard' on it and he wore other army uniforms just as often.

A 'play regiment' was specially set up for him, comprising the sons of the highest officers. Second-class naval lieutenant Derevenko was appointed commander. Military exercises, marches, inspections and gymnastic exercises to music were organized, with strict discipline being observed. On Alexei's birthday in 1912 an inspection of the 'play regiment' was organized on the parade ground, in the presence of Alexei and the cream of St Petersburg society.

Alexei's interest in military matters undoubtedly increased when the First World War broke out and Nicholas II departed for the real army. It was the first time that the tsar and his family had been separated from each other so long. Alexei in particular missed his father, to whom he was devoted. On the other hand Alexandra realized that in the difficult circumstances of war the tsar had to act alone without any moral support. Gillard writes very well about this: 'The tsar's loneliness became burdensome. He was robbed of his greatest consolation, his family.' In 1915 the tsarina wrote to General Headquarters in Mogilyov [now in Belarus]: 'Our "Baby" has again gradually started asking if you couldn't find a place for him at the Headquarters, but he would also be very upset if he had to leave me.' It was a wretched situation for both of them, but in Autumn 1915 the tsar and his heir went to the front together. Nicholas II thought the journey to Headquarters would broaden his horizons. The tsarevich replaced his sailor's cap with a military uniform. What Alexei did at Headquarters and how he conducted himself is known in some detail due to the copious correspondence between Nicholas and Alexandra and the reminiscences of their contemporaries.

PORTRAIT OF TSAR NICHOLAS II
WITH PORTRAIT SKETCH OF TSAREVICH
ALEXEI NIKOLAYEVICH, 1913
AFTER THE ORIGINAL BY
VALENTIN ALEXANDROVICH SEROV
Michail Viktorovich Rundaltsov (1871–1935)
etching, watercolour, ink

CAT. NR. 48

HERMITAGE✤AMSTERDAM

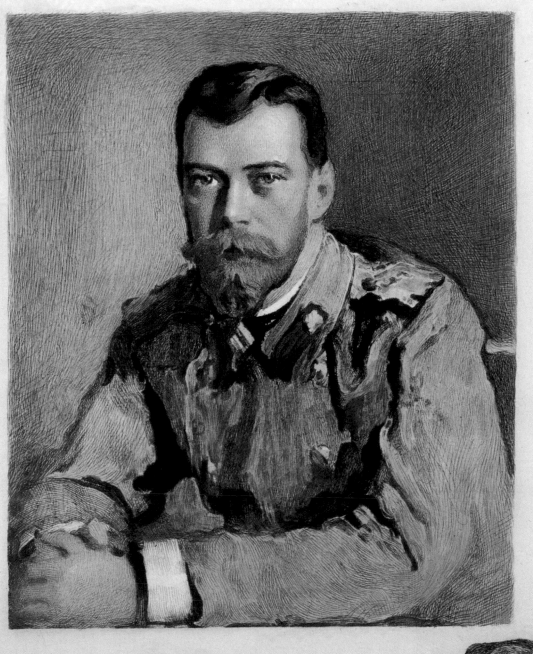

The tsar gave his son lessons about life on campaign. He made space for him in his modestly furnished room with two beds and a table. The tsar took him with him when he went to the front, visited hospitals or distributed payments; on these occasions the tsarevich always wore a uniform appropriate to the regiments that were symbolically under his command. In their free time they walked along the River Dnieper, went on boat trips or to the cinema. Nicholas II's Diaries are literally a daily account of Alexei's doings. As the son of doctor Botkin wrote, 'Alexei Nikolaevich worshipped his father and it was moving to see how he always went with him wherever he went.'

Later Alexei's teachers joined him at Headquarters. But although he began his lessons again, they were not as frequent or regular as was desirable. Shabelski, the archpriest of the Russian army and fleet was at Headquarters when the tsarevich arrived. He recalls in his memoirs that, 'Alexei Nikolaevich always breakfasted at the common table, sitting on the left hand side of the tsar.' In the afternoon he ate with his teachers [...]. Alexei Nikolaevich's illness had a strong influence on his upbringing and education. As an invalid he was allowed a great deal of latitude and he was forgiven for things that would not have been acceptable in a healthy individual. In fact the limits of the permissible were often transgressed. To ensure that he did not become overtired, care was taken not to cram him, with all the obvious drawbacks for his progress. For instance in Autumn 1916 Alexei Nikolaevich became 13 – high school age, that is, or that of a third-class cadet – but he was unable to do fractions in arithmetic. The fact that he had fallen behind in his education could also have

been due to the choice of mentors'. Shabelski was not only concerned about the heir when he was in the palace or at Headquarters; he was also thinking about his future. 'I met him twice a day in the Palace, I saw how he related to people, how he played and indulged in pranks, and I asked myself "When he grows up, what kind of a tsar will he be?"' But he did not come to any conclusion about him. He ended his remarks by saying, 'The Lord has endowed the unhappy boy with marvellous natural qualities – a quick and powerful mind, resourcefulness, a warm compassionate heart, and, for a tsar, a brilliant simplicity; his mental and spiritual beauty matched his physical beauty.'

At Headquarters Alexei made friends with the cadets. They organized lessons and war games in the city gardens. He began to love the brown bread the soldiers ate. Sometimes he even refused the food at Headquarters, saying, 'That's not what soldiers eat.'

Many people have told the story of the tsarevich who stood on guard by his father's tent. 'In the summer there was one task the heir to the throne fulfilled that revealed both his love for army exercises and his affection for his father. In the morning [...] before his father entered the tent Alexei was already standing with his rifle at attention before the entrance, to salute his Imperial Highness when he arrived [...] and when the latter left the tent once more Alexei saluted him again; only then did he go off duty.' The equerry Anatoli Mordvinov adds to Shabelski's memories this detail, '[...] while he was waiting for his father's arrival holding his tiny rifle [...], he gave a salute; the most experienced junior officer in a model regiment of the time of Nicholas I [1825-1855] could not have

performed this exercise with greater competence and elegance.' Everyone who saw the tsarevich after his stay in the Headquarters, remarked that he was taller and more manly than before; gone were his childish fragility and his chubby cheeks, gone too was his timidity.

Alexei's services were highly prized; in Autumn 1905 he was awarded the medal of Saint George and in May 1916 he was promoted to the rank of corporal. He spent the whole year of 1916 in the Headquarters. At the beginning of 1917 he rejoined his sisters in Tsarskoe Selo. Events then developed at breakneck speed, and on 2 March 1917 the tsar signed the document in Pskov declaring his abdication and that of Alexei, his heir. Before his definitive abdication, Nicholas II summoned his personal physician, professor Sergei Fyodorov; in the presence of Shabelski they had the following conversation:

- 'Tell me honestly, Sergei Petrovich: can Alexei Nikolaevich ever be completely cured?'

- 'If Your Majesty believes in miracles, he can, because miracles have no limits. But if you want to know what science has to say about it, I have to tell you that there are no known cases in science of a complete cure for this disease.'

- 'So, you regard his disease as incurable?'

- 'Yes, Your Majesty.'

The tsarevich learned of the abdication from his tutor Pierre Gillard.

An icon has been preserved for posterity to the memory of the martyr, the young tsarevich Alexei.

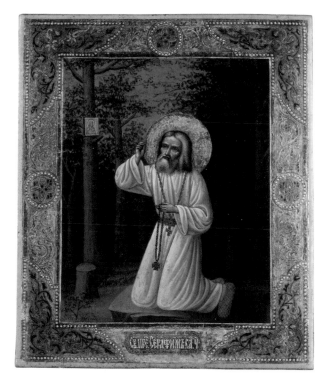

THE HOLY SERAPHIM OF SAROV
Unknown icon painter
(early 20th century)
panel, tempera
Stories are told of the miracles of the hermit and monk Serafim of Sarov (1754/1759-1833) by which he healed the sick and cured infertility. Alexandra Fyodorovna turned to him after failing to produce an heir to the throne. Her prayers were heard and a year later Alexei was born.

CAT. NR. 27

NICHOLAS II'S LIBRARY, *1917*
Karl Karlovich Kubesch
(late 19th/early 20th century)
photo
The library of Nicholas II
is the only original interior of
the Tsar's private apartments
that has been preserved.

CAT. NR. 78

FURTHER READING

Grand Duchess Olga Alexandrovna,
Мемуары
(Memoirs),
Moscow 2003.

Grand Duke Alexander Mikhailovich,
Книга воспоминаний
(Book of memories),
Moscow 1991.

Grand Duke Gavril Konstantinovich,
Из хроники нашей семьи
(From the chronicle of our family),
St Petersburg 1993.

Maslov, V.,
Елизавета федоровна. Биография
(Elizaveta Fedorovna. A biography),
Moscow 2004.

Oldenburg, S.S.,
Царствование императора Николая II
(The reign of Tsar Nicholas II),
St Petersburg 1991.

Shelayev, Y. et.al.,
Николай II. Страницы жизни
(Nicholas II. Pages from a life),
St Petersburg 1998.

Volkonsky, Prince Sergei,
Мои Воспоминания
(My memories), part II,
St Petersburg 1992.

Witte, S.Y.,
Воспоминания
(Reminiscences), vol. II,
Moscow 1994.

Дневники императора Николая II
(The Diaries of Tsar Nicholas II),
Moscow 1991.

Нива
(Niva), Nr. 22 (1896).

РГИА
(Russian Historical State Archive),
Stock 468, list 42.

Священное коронование Их
Императорских Величеств и
последующие торжества в Москве
*(The holy coronation of Their Imperial Highnesses
and the ensuing festivities in Moscow),*
St Petersburg 1896.

Paintings

15
Laurits Regner Tuxen (1853–1927)
THE CORONATION OF TSAR NICHOLAS II AND
TSARINA ALEXANDRA FYODOROVNA, 1898
Oil on canvas
66 x 87.5 cm / Signed, below left: 'L. Tuxen. 1898' / Provenance: 1914,
State Museum of Ethnography of the Peoples of the USSR / Inv. no.
ERZh-1638 / A.P.

16
Alexei Vasilyevich Tyranov (1808–1859)
INTERIOR OF THE CATHEDRAL AT THE
WINTER PALACE, 1829
Oil on canvas
146 x 108 cm / Signed, on reverse: 'P[ainted by] A. Tyranov. 1829' /
Provenance: 1956, Central Depot of the City's Museum Palaces, previously
of Catharina Palace, Tsarskoye Selo / Inv. no. ERZh-2431 / A.P.

17
François Flameng (1856–1923)
PORTRAIT OF DUCHESS ZINAIDA YUSUPOVA, 1894
Oil on canvas
125.5 x 94 cm / Signed, on column base, right: 'François Flameng, 1894' /
Provenance: 1941, State Museum of Ethnography of the Peoples of the
USSR, previously of' the Dukes Yusupov collection, St Petersburg /
Inv. no. ERZh-1371 / A.P.

18
Vasili Pavlovich Chudoyarov (1831–1892)
PORTRAIT OF GRAND DUKE ALEXANDER
ALEXANDROVICH AS HEIR TO THE THRONE,
late 1870s/early 1880s
Oil on canvas
88.2 x 75 cm (oval) / Signed, in margin, scratched, left: 'V. Chudoyarov' /
Provenance: 1941, State Museum of Ethnography of the Peoples of the
USSR / Inv. no. ERZh-646 / A.P.

19
Viktor Karlovich Stemberg (1863–after 1917)
PORTRAIT OF SOFIA RAYEVSKAYA, 1907
Oil on canvas
143 x 115 cm / Provenance: 1941, State Museum of Ethnography of
the Peoples of the USSR, previously of the Rayevski family collection /
Inv. no. ERZh-1395 / A.P.

20
Unknown Artist (second half 19th century)
PORTRAIT OF GRAND DUCHESS
MARIA FYODOROVNA, 1870s
Oil on canvas
62 x 54 cm / Provenance: 1941, State Museum of Ethnography of
the Peoples of the USSR / Inv. no. ERZh-2778 / A.P.

21
Unknown Artist (second half 19th century)
PORTRAIT OF TSAR ALEXANDER III, late 19th century
Oil on canvas
55 x 47 cm / Provenance: 1994, Acquisitions Committee of the
State Hermitage Museum / Inv. no. ERZh-3247 / A.P.

22
Unknown Artist (second half 19th/early 20th century)
PORTRAIT OF TSAR NICHOLAS II, 1915–1916
Oil on canvas
187.5 x 106.5 cm / Provenance: 1998, Acquisitions Committee of the
State Hermitage Museum / Inv. no. ERZh-3270 / A.P.

23
Unknown Artist (second half 19th/early 20th century)
PORTRAIT OF ADMIRAL ALEXANDER RUSIN, early 20th century
Oil on canvas
91 x 78 cm / Provenance: 1941, State Museum of Ethnography of the
Peoples of the USSR / Inv. no. ERZh-42 / A.P.

ICONS

24
A.I. Tsepkov (late 19th/early 20th century)
ST NICHOLAS THE MIRACLE WORKER AND
ST TSARINA ALEXANDRA, 1898
Panel, tempera, gilt
31.3 x 26.8 cm / Signed, below right: 'A.I. Tsepkov, icon painter of the
village of Mstera, 1898' / Provenance: 1953, Uspenski family collection /
Inv. no. ERZh-2285 / A.P.

25
Osip Semyonovich Chirikov (?–1903)
THE RAISING OF THE CROSS
Panel, tempera
31.2 x 26.2 cm / Signed, in margin, below right: 'painted by Chirikov' /
Provenance: 1959, State Museum Fund, previously of the Marble Palace /
Inv. no. ERZh-2525 / A.P.

26
Unknown icon painter (late 19th/early 20th century)
THE ELECTED HOLY METROPOLITANS OF
MOSCOW PYOTR, IONA, PHILIP AND ALEXI
Panel, oil, metal frame
36 x 30 cm / Provenance: 1956, Museum for the History of Religion /
Inv. no. ERZh-2422 / A.P.

27
Unknown icon painter (early 20th century)
THE HOLY SERAPHIM OF SAROV
Panel, tempera
31 x 26.5 cm / Provenance: 1941, State Museum of Ethnography of the
Peoples of the USSR / Inv. no. ERZh-3136 / A.P.

28
Vasili Vasilyevich Vasilyev (1829–1894) (icon)
Ovchinnikov firm, Moscow (frame)
THE LOYAL PRINCE ALEXANDER NEVSKI,
THE MIRACLE WORKER ST TITUS AND
THE MARTYR ST POLYCARPUS, 1879
Panel, oil, silver, diamonds, pearls, enamel, engraving, piercing, gilt

128 x 85 cm / Marks: below double-headed eagle: factory, unknown assayer, Moscow mark; silver mark 84. Inscription on a plate on frame: 'Diligently made and presented to Tsar Alexander II by I.O. Kozmin, O.G. Samsonov, V.A. Gostevoi, P.A. Ovchinnikov, M.I. Fukova, D.A. Petrov, M.A. and A.A. Alexandrov, E.I. Sivochin, the academic V.V. Vasilyev and the counsellor Z.I. Dechtyarev' / Provenance: 1922, Church of the Icon of the Saviour Not-Made-By-Human-Hand at the Winter Palace / Inv. no. ERO-7257 / L.Z., K.O.

29
K. Yemelyanov (icon)
Ivan Petrovich Chlebnikov firm, Moscow (silver filigree frame)
IOASAPH OF BELGOROD, 1911
Panel, oil, mica, brocade, silver, filigree
31 x 26.6 cm / Marks: below arms: manufacturer, Moscow assay office 1908–1917, assayer's mark 84. Signed, below right: 'painted by Yemelyanov 1911' / Provenance: 1956, Central Depot of the City's Museum Palaces, previously of Alexander Palace, Tsarskoye Selo / Inv. no. ERO-8761 / L.Z., K.O.

30
Vasili Pavlovich Guryanov (icon)
Dmitri Lukich Smirnov studio, Moscow (frame)
THE FEODOR MOTHER OF GOD, 1913
Panel, silk, silver, tempera, enamel, filigree
35.5 x 31.2 cm / Marks: studio, Moscow assay office 1908–1917. Signed, below right: 'in 1913 V.P. Guryanov painted this icon' / Provenance: 1956, Central Depot of the City's Museum Palaces, previously of Alexander Palace, Tsarskoye Selo / Inv. no. ERO-8753 / A.P.

31
K.I. Konov, Olovyanishnikov family firm, Moscow (1910s) (frame)
THE MOTHER OF GOD OF THE SIGN
Panel, tempera, silver, emerald, amethysts, tourmaline, aquamarine
27 x 22.4 cm / Marks: master, Moscow assay office 1908–1917, assayer's mark 84. Inscription on silver plate, on reverse: 'For Her Imperial Highness Tsarina Alexandra Fyodorovna in memory of her visit to Novgorod on 11 December 1916 from the Novgorod Association of Merchants' / Provenance: 1956, Central Depot of the City's Museum Palaces, previously of Alexander Palace, Tsarskoye Selo / Inv. no. ERO-8748 / L.Z., K.O.

WATERCOLOURS, DRAWINGS, ENGRAVINGS

32
Karel (Carl) Osipovich Brozh (1836–1901)
COURT BALL AT THE ST NICHOLAS HALL OF THE WINTER PALACE, late 1880s
Pencil, and pen with ink on card
41.0 x 63.8 cm / Signed, below right: 'K. Brozh' / Provenance: 1941, State Museum of Ethnography of the Peoples of the USSR / Inv. no. ERR-6000 / G.P.

33
Karel (Carl) Osipovich Brozh (1836–1901)
WEDDING OF GRAND DUCHESS XENIA ALEXANDROVNA AND GRAND DUKE ALEXANDER MICHAILOVICH ON 25 JULY 1894 AT THE CHURCH OF THE GREAT PALACE OF PETERHOF, 1894
Pen and brush with ink on card
38.5 x 58.4 cm / Signed, below right: 'K. Brozh' / Provenance: 1941, State Museum of Ethnography of the Peoples of the USSR / Inv. no. ERR-5999 / G.P.

34
Dmitri Nikolayevich Kardovski (1866–1943)
BALL OF THE MEETING OF THE PETERSBURG COUNCIL OF NOBLES ON 23 FEBRUARY 1913, 1915
Watercolour, gouache, white bodycolour on paper, pasted on canvas
89 x 133 cm / Signed, below right: 'D. Kardovski, 1915' / Provenance: 1941, State Museum of Ethnography of the Peoples of the USSR, previously in the Winter Palace / Inv. no. ERR-5990 / G.P.

35
Yelena Nikandrovna Klokacheva (1871–after 1915)
PORTRAIT OF GRIGORI RASPUTIN, 1914
Colour pencil, pastel chalk on card
81.5 x 56 cm / Signed, right: 'E. Klokacheva, June 1914' / Provenance: 1954, Museum of the Revolution / Inv. no. ERR-5432 / G.P.

36
Yelena Petrovna Samokish-Sudkovskaya (1863–1924)
CORONATION BANQUET OF NICHOLAS II AT THE FACET PALACE OF THE MOSCOW KREMLIN ON 14 MAY 1896, 1896
Ink, white bodycolour on card
40.6 x 32.8 cm / Signed in ink, below right: 'E.P. Samokish-Sudkovskaya'; in pencil, centre: 'Coronation Banquet of Tsar Nicholas II' / Provenance: 1941, State Museum of Ethnography of the Peoples of the USSR / Inv. no. ERR-5993 / G.P.

37
Maria Vasilyevna Etlinger (Eristova) (?–1934)
PORTRAIT OF GRAND DUKE NIKOLAI MICHAILOVICH, 1882
Watercolour, colour and graphite pencil, pastel chalk, lacquer on paper
56.5 x 43 cm (oval) / Signed, right: 'Mary, 1882' / Provenance: 1941, State Museum of Ethnography of the Peoples of the USSR, previously of the Palace of Grand Duke Michail Nikolayevich / Inv. no. ERR-5225 / G.P.

38
Maria Vasilyevna Etlinger (Eristova) (?–1934)
PORTRAIT OF GRAND DUKE ALEXANDER MICHAILOVICH AS A YOUNG MAN, 1882
Watercolour, colour and graphite pencil, pastel chalk, lacquer on paper
57 x 43.5 cm (oval) / Signed, right: 'Mary, 1882' / Provenance: 1941, State Museum of Ethnography of the Peoples of the USSR, previously of the Palace of Grand Duke Michail Nikolayevich / Inv. no. ERR-5229 / G.P.

39
Alois Gustav (Aloizi Petrovich) Rockstuhl (1798–1877)
PORTRAIT OF GRAND DUKE, THE HEIR TO THE
THRONE, TSAREVICH NIKOLAI ALEXANDROVICH AS
ONE-YEAR-OLD CHILD, 1869
Watercolour, gouache on ivory
11 x 9 cm (oval)
Signed along oval, left: '1869. Rockstuhl'; on reverse: 'portrait de
Monseigneur le Grand Duc Nicolay Alexandrowitch, peint en 1869 par le
peintre de sa Majesté l'Empereur-professeur A. De Rockstuhl chevalier' /
Provenance: 1941, State Museum of Ethnography of the Peoples of the
USSR, previously of Anichkov Palace / Inv. no. ERR-45 / G.P.

40
R. de San-Gallo (late 19th/early 20th century)
PORTRAIT OF COUNT FELIX SUMAROKOV-ELSTON, C. 1908
Watercolour, gouache on ivory
9.4 x 7.0 cm (oval) / Signed along oval, left: 'R. de San Gallo' / Provenance:
1941, State Museum of Ethnography of the Peoples of the USSR, previously
of Yusupov Palace / Inv. no. ERR-61 / G.P.

41
Unknown Artist (early 20th century)
PORTRAIT OF TSAR NICHOLAS II, c. 1913
Silver, enamel, fresco
8.7 x 7.0 cm (oval) / Provenance: 1951, State Depot of Valuables of the
Ministry of Finance of the USSR / Inv. no. ERO-8882 / G.P.

42
Unknown Artist (early 20th century)
PORTRAIT OF TSAR MICHAIL FYODOROVICH, c. 1913
Silver, enamel, fresco / 8.8 x 6.8 cm (oval) / Provenance: 1951,
State Depot of Valuables of the Ministry of Finance of the USSR /
Inv. no. ERO-8881 / G.P.

43
Arkadi Alexandrovich Chumakov (1868–1948)
IPATIEV MONASTERY IN KOSTROMA, 1913
From the commemorative album of drawings, KOSTROMA
Watercolour on paper in card passe-partout
Watercolour 16.9 x 24.8 cm; passe-partout 26.5 x 34.8 cm / Signed,
below right: 'A. Chumakov'. Inscriptions: on passe-partout, left:
'Ipatiev Monastery'; in pencil on passe-partout, right: 'from books received
no. 820 25 July 1913 from His Highness's chamber' / Provenance: 1956,
Central Library of the State Hermitage Museum / Inv. no. ERR-5487 /
A.S.

44
Arkadi Alexandrovich Chumakov (1868–1948)
THE ROMANOV ROOMS AT IPATIEV MONASTERY, 1913
From the commemorative album of drawings, KOSTROMA
Watercolour on paper in card passe-partout
Watercolour 24.7 x 16.8 cm; passe-partout 34.8 x 26.5 cm (passe-partout) /
Signed, below right: 'A. Chumakov'. Inscription on passe-partout, left:
'The Romanov / Provenance: 1956, Central Library of the State Hermitage
Museum / Inv. no. ERR-5491 / A.S.

45
Fernand Desmoulin (1853–1914)
CORONATION PORTRAIT OF TSAR NICHOLAS II, 1896
Etching
58.5 x 44.3 cm; 80 x 56.1 cm / Signed, below left: 'F. Desmoulin' / Provenance:
original collection of the State Hermitage Museum / Inv. no. ERG-33635 /
G.M.

46
Michail Viktorovich Rundaltsov (1871–1935)
PORTRAIT OF TSARINA ALEXANDRA FYODOROVNA, 1905
Etching
62.5 x 47.5 cm; 96 x 67.5 cm / Signed, left: 'M. Rundaltsev 1905' / Provenance:
original collection of the State Hermitage Museum / Inv. no. ERG-16871 /
G.M.

47
Michail Viktorovich Rundaltsov (1871–1935)
PORTRAIT OF THE HEIR TO THE THRONE
TSAREVICH ALEXEI NIKOLAYEVICH WITH SKETCHES OF
PORTRAITS OF HIS ELDER SISTERS GRAND DUCHESSES
TATYANA, MARIA AND ANASTASIA, 1911
Dry-point
46.5 x 33.8 cm; 53 x 36.2 cm / Signed, below left: 'Mich. Rundaltsov 1911' /
Provenance: original collection of the State Hermitage Museum / Inv. no.
ERG-28932 / G.M.

48
Michail Viktorovich Rundaltsov (1871–1935)
PORTRAIT OF TSAR NICHOLAS II WITH PORTRAIT
SKETCH OF TSAREVICH ALEXEI NIKOLAYEVICH, 1913
After the original by Valentin Alexandrovich Serov
Etching, watercolour, ink
28.2 x 21.5 cm; 52 x 37.5 cm / Signed, below left: 'M. Rundaltsov. 1913' /
Provenance: original collection of the State Hermitage Museum / Inv. no.
ERG-28931v
G.M.

49
Michail Viktorovich Rundaltsov (1871–1935)
PORTRAIT OF TSAREVICH ALEXEI NIKOLAYEVICH, 1917
Etching, watercolour
42.7 x 34.0 cm; 71.5 x 62.0 cm / Signed, below: 'Mich. Rundaltsov 1917' /
Provenance: 1951, Artillery Museum / Inv. no. ERG-33987 / G.M.

50
Michail Viktorovich Rundaltsov (1871–1935)
PORTRAIT OF TSAR NICHOLAS II WITH PORTRAIT
SKETCHES OF TSARS ALEXANDER I AND NICHOLAS I, 1912
Etching
28.5 x 13.8 cm; 52.0 x 35.8 cm / Signed, below right: 'Mich. Rundaltsov 1912'
/ Provenance: 1951, Artillery Museum / Inv. no. ERG-33983 / G.M.

51
Karl Anton Schultz (1830–1884)
PORTRAIT OF GRAND DUKE ALEXEI ALEXANDROVICH,
1880s
After a photo by C. Bergamasco

Lithograph
45 x 37 cm; 79.5 x 56.5 cm / Provenance: original collection of the State Hermitage Museum / Inv. no. ERG-33622 / G.M.

52
Unknown lithographer *(late 19th/early 20th century)*
PORTRAIT OF TSARINA MARIA FYODOROVNA, *1880s*
After the original by F. Flameng
Lithograph, colour print
62.8 x 37.2 cm; 77 x 51 cm / Signed, below portrait: 'François Flameng' / Provenance: original collection of the State Hermitage Museum / Inv. no. ERG-28933 / G.M.

53
Earnest Karlovich Lipgart *(1847–1932)*
MENU OF THE BANQUET AT THE MOSCOW KREMLIN FOR THE CORONATION OF NICHOLAS II ON 25 MAY 1896, *1896*
Colour lithograph
34.5 x 24.5 cm / Signed, below right: 'Lipgart' / Provenance: original collection of the State Hermitage Museum / Inv. no. ERG-10628/8 / G.M.

54
Viktor Michailovich Vasnetsov *(1848–1926)*
MENU OF THE SUPPER GIVEN BY MOSCOW'S GOVERNOR-GENERAL GRAND DUKE SERGEI ALEXANDROVICH ON 20 MAY 1896, *1896*
Colour lithograph
41 x 24.5 cm / Provenance: after 1917, probably from the M.G. Mecklenburg-Strelitski collection / Inv. no. Lm 1002 lit. / I.T.

55
Albert Nikolayevich Benois *(1852–1936)*
MENU OF THE BANQUET FOR REPRESENTATIVES OF THE ESTATES AT THE ALEXANDER HALL OF THE KREMLIN PALACE, 19 MAY 1896, *1896*
Colour lithograph
37.5 x 27 cm / Provenance: after 1917, probably from the M.G. Mecklenburg-Strelitski collection / Inv. no. Lm 1004 lit. / I.T.

56
Sergei Ivanovich Yaruzhinski *(1862–1947)*
MENU OF THE BANQUET AT THE GREAT KREMLIN PALACE FOR THE TERCENTENARY OF THE HOUSE OF ROMANOV, 25 MAY 1913, *1913*
Colour lithograph
45 x 15 cm / Ex-libris on reverse: 'Library of Duke Michail Georgievich Mecklenburg' / Provenance: after 1917, probably from the M.G. Mecklenburg-Strelitski collection / Inv. no. Lm 1001 lit. / I.T.

57
Boris Vasilyevich Zvorykin *(1872–after 1935)*
CONCERT PROGRAMME FROM THE CHAPEL OF RELIGIOUS CHORAL MUSIC CONDUCTED BY F.A. IVANOV AT THE GREAT KREMLIN PALACE ON 27 MAY 1913 DURING THE CEREMONIES IN MOSCOW FOR THE TERCENTENARY OF THE HOUSE OF ROMANOV, *1913*
Colour lithograph
66 x 27.5 cm / Provenance: after 1917, probably from the M.G. Mecklenburg-Strelitski collection / Inv. no. Lm 1003 lit. / I.T.

PHOTOS

58
Karl Karlovich Bulla *(1853–1929)*
MEETING OF THE STATE DUMA, *1900s*
Silver bromide print
22 x 28.4 cm; 26.2 x 36.5 cm / Firm name on passe-partout: photo studio / Provenance: 1941, State Museum of Ethnography of the Peoples of the USSR / Inv. no. ERFt-2889 / G.M.

59
Karl Karlovich Bulla *(1853–1929)*
THE SENATE BUILDING, *1901*
Silver bromide print
20.5 x 27.7 cm / Mark on reverse: photo studio. Pencil inscription: 'Centenary Senate' / Provenance: 1941, State Museum of Ethnography of the Peoples of the USSR / Inv. no. ERFt-14 / T.P.

60
Karl Karlovich Bulla *(1853–1929)*
OPENING OF THE FIRST TRAMRAIL IN ST PETERSBURG, *1907*
Photo
16.2 x 22 cm / Mark on reverse: photo studio 'Photographer K.K. Bulla St Petersburg, Nevski Prospekt 54'. Pencil inscription: 'Die electrische Tramway Verbindung in Petersburg' / Provenance: 1941, State Museum of Ethnography of the Peoples of the USSR / Inv. no. ERFt-216 / T.P.

61
Karl Karlovich Bulla *(1853–1929)*
UNVEILING OF THE MONUMENT TO TSAR ALEXANDER III ON ZNAMENSKAYA SQUARE IN ST PETERSBURG, *1909*
Photo
20.2 x 27.6 cm / Provenance: 1941, State Museum of Ethnography of the Peoples of the USSR / Inv. no. ERFt-164 / T.P.

62
Karl Karlovich Bulla *(1853–1929)*
POPULAR FESTIVAL ON OBVODNY CANAL, *1890s*
Photo
20.5 x 27.7 cm / Mark on reverse: photo studio 'Photographer K.K. Bulla SPb, Nevski Prospekt 48. Photograph C.O. Bulla St Petersburg Newsky pr., 48' / Provenance: 1941, State Museum of Ethnography of the Peoples of the USSR / Inv. no. ERFt-186 / T.P.

63
Karl Karlovich Bulla *(1853–1929)*
OPENING OF THE PETER THE GREAT BRIDGE (BOLSHEOKHTINSKY BRIDGE) OVER THE NEVA, *1911*
Photo
23.7 x 29.5 cm / Provenance: 1941, State Museum of Ethnography of the Peoples of the USSR / Inv. no. ERFt-129 / T.P.

64
K.F. Hann & Co, Photo Studio
IMPERIAL SPEECH BY TSAR NICHOLAS II, *1906*
Silver bromide print
43.8 x 55.8 cm; 27.4 x 37.1 cm / Inscriptions on passe-partout: 'Photo of

His Highness's Court, F. Gan and Co Tsarskoye Selo'; 'Coronation Speech
of Tsar Nicholas II/ on the Day of the Ceremonial Opening of the State
Council and the State Duma/ at the Imperial Winter Palace on 27 April
1906' / Provenance: 1941, State Museum of Ethnography of the Peoples of
the USSR / Inv. no. ERFt-26766 / T.P.

65
K.F. Hann & Co, Photo Studio
BICENTENARY MEETING OF THE SENATE, 1909
Silver bromide print
22.2 x 28.3 cm; 33.5 x 43.5 cm / Marks: on passe-partout, right: firm;
reverse: firm name. Pencil inscription: 'Bicentenary meeting of the Senate.
St Petersburg Senate.1909' / Provenance: 1941, State Museum of
Ethnography of the Peoples of the USSR / Inv. no. ERFt-26765 / G.M.

66
Carl Sonne
PORTRAIT OF THE DANISH KING CHRISTIAN IX HOLD-
ING TSAREVICH ALEXEI NIKOLAYEVICH, 1904
Photo in passe-partout
15 x 10.3 cm; 16.5 x 10.7 cm / Marks on passe-partout, below: 'Carl Sonne,
Kyobenhavn. Court Photographer'; reverse: photo studio. Ink inscription:
'The crown princes at the baptism of the heir to the throne, Tsarevich
Alexei Nikolayevich' / Provenance: 1941, State Museum of Ethnography
of the Peoples of the USSR, previously of the Winter Palace / Inv. no.
ERFt-29198 / T.P.

67
Karl Karlovich Kubesch (late 19th/early 20th century)
THE MALACHITE HALL IN THE WINTER PALACE, 1917
Silver bromide print
16.8 x 22.5 cm / Provenance: 1941, State Museum of Ethnography of the
Peoples of the USSR / Inv. no. ERFt-21270 / T.P.

68
Karl Karlovich Kubesch (late 19th/early 20th century)
THE MOORISH HALL IN THE WINTER PALACE, 1917
Silver bromide print
16.8 x 22.5 cm / Provenance: 1941, State Museum of Ethnography of the
Peoples of the USSR / Inv. no. ERFt-21231 / T.P.

69
Karl Karlovich Kubesch (late 19th/early 20th century)
EMPIRE-STYLE SALON (WHITE SALON), 1917
Photo
20.5 x 9.7 cm / Pencil inscription on reverse: 'Winter Palace. Half of
Al. Fyod. the White Salon. F-567' / Provenance: 1941, State Museum of
Ethnography of the Peoples of the USSR / Inv. no. ERFt-21226 / T.P.

70
Karl Karlovich Kubesch (late 19th/early 20th century)
THE SILVER SALON, 1917
Photo
16.9 x 22.4 cm / Pencil inscription on reverse: 'Winter Palace. Half of
Al.F. the Silver Salon. F-561' / Provenance: 1941, State Museum of
Ethnography of the Peoples of the USSR / Inv. no. ERFt-21221 / T.P.

71
Karl Karlovich Kubesch (late 19th/early 20th century)
ALEXANDRA FYODOROVNA'S SALON STUDY, 1917
Photo
17 x 22.3 cm / Pencil inscription on reverse: 'Winter Palace. Al. F.'s Salon
Study F-564' / Provenance: 1941, State Museum of Ethnography of the
Peoples of the USSR / Inv. no. ERFt-21224 / T.P

72
Karl Karlovich Kubesch (late 19th/early 20th century)
BEDROOM IN NICHOLAS II'S WING, 1917
Photo
16.8 x 22.5 cm / Pencil inscription on reverse: 'Winter Palace. N. II and
Al. F.'s Bedroom F-560' / Provenance: 1941, State Museum of Ethnography
of the Peoples of the USSR / Inv. no. ERFt-21220 / T.P.

73
Karl Karlovich Kubesch (late 19th/early 20th century)
BEDROOM IN NICHOLAS II'S WING, 1910s
Photo
17 x 22.5 cm / Provenance: 1941, State Museum of Ethnography of the
Peoples of the USSR / Inv. no. ERFt-21218 / T.P.

74
Karl Karlovich Kubesch (late 19th/early 20th century)
ALEXANDRA FYODOROVNA'S BOUDOIR, 1917
Photo
16.5 x 22.3 cm / Pencil inscription on reverse: 'Winter Palace. Half of
Al. F.'s Lilac Boudoir F-557' / Provenance: 1941, State Museum of
Ethnography of the Peoples of the USSR / Inv. no. ERFt-21217 / T.P.

75
Karl Karlovich Kubesch (late 19th/early 20th century)
ALEXANDRA FYODOROVNA'S BOUDOIR, 1917
Silver bromide print
17 x 22.3 cm / Provenance: 1941, State Museum of Ethnography of
the Peoples of the USSR / Inv. no. ERFt-21216 / T.P.

76
Karl Karlovich Kubesch (late 19th/early 20th century)
NICHOLAS II'S STUDY, 1917
Photo
22.5 x 16.7 cm / Pencil inscription on reverse: 'Winter Palace Study Nic. II
F-554' / Provenance: 1941, State Museum of Ethnography of the Peoples of
the USSR / Inv. no. ERFt-21214 / T.P.

77
Karl Karlovich Kubesch (late 19th/early 20th century)
NICHOLAS II'S STUDY, 1917
Silver bromide print
22.3 x 16.5 cm / Provenance: 1941, 1965, Scientific Library of the State
Hermitage Museum / Inv. no. ERFt-29571 / T.P.

78
Karl Karlovich Kubesch (late 19th/early 20th century)
NICHOLAS II'S LIBRARY, 1917
Photo

16.7 x 22.3 cm / Pencil inscription on reverse: 'Winter Palace. Library N.II F-547' / Provenance: 1941, State Museum of Ethnography of the Peoples of the USSR / Inv. no. ERFt-21208

Nicholas II's library is the only interior of the tsar's apartment to have survived intact. / T.P.

79
Karl Karlovich Kubesch *(late 19th/early 20th century)*
NICHOLAS II's BILLIARD ROOM, 1917
Photo
16.5 x 22.6 cm / Pencil inscription on reverse: 'Winter Palace. Billiard Room N.II F-545' / Provenance: 1941, State Museum of Ethnography of the Peoples of the USSR / Inv. no. ERFt-21206 / T.P.

80
Karl Karlovich Kubesch *(late 19th/early 20th century)*
SOLDIERS IN THE MINISTERIAL RECEPTION ROOM
OF NICHOLAS II AFTER THE STORMING OF THE
WINTER PALACE, 1917
Photo
16.8 x 22.4 cm / Pencil inscription on reverse: 'Winter Palace Ministerial Reception Room of N II F-544' / Provenance: 1941, State Museum of Ethnography of the Peoples of the USSR / Inv. no. ERFt-21205 / T.P.

81
Karl Karlovich Kubesch *(late 19th/early 20th century)*
SMALL DINING ROOM, 1917
Photo
22.5 x 16.8 cm / Pencil inscription on reverse: 'Winter Palace. Half of A.F. Small Dining Room. F-572' / Provenance: 1941, State Museum of Ethnography of the Peoples of the USSR / Inv. no. ERFt-21230 / T.P.

82
Karl Karlovich Kubesch *(late 19th/early 20th century)*
THE WHITE HALL. ALEXANDER KERENSKI'S GUARDS, 1917
Page from the 'Winter Palace in 1917' album
Silver bromide print
17 x 23 cm / Provenance: 1981, Archive of the State Hermitage Museum / Inv. no. ORDF / V.M.

83
Karl Karlovich Kubesch *(late 19th/early 20th century)*
ALEXANDRA FYODOROVNA'S BOUDOIR. AFTER THE
STORMING OF THE PALACE, 1917
Page from the 'Winter Palace in 1917' album
Silver bromide print
17 x 22.5 cm / Provenance: 1981, Archive of the State Hermitage Museum / Inv. no. ORDF / V.M.

84
Karl Karlovich Kubesch *(late 19th/early 20th century)*
NICHOLAS I's UPPER STUDY.
AFTER THE STORMING OF THE PALACE, 1917
Page from the 'Winter Palace in 1917' album
Silver bromide print
17 x 22.5 cm / Provenance: 1981, Archive of the State Hermitage Museum / Inv. no. ORDF / V.M.

85
Karl Karlovich Kubesch *(late 19th/early 20th century)*
NICHOLAS II's STUDY. AFTER THE STORMING
OF THE PALACE, 1917
Page from the 'Winter Palace in 1917' album
Silver bromide print
17 x 22 cm / Provenance: 1981, Archive of the State Hermitage Museum / Inv. no. ORDF / V.M.

86
Karl Karlovich Kubesch *(late 19th/early 20th century)*
PORTRAIT OF KONSTANTIN POBEDONOSTSEV, 1902
Albumin print, in wooden frame
15.5 x 9 cm; 20.3 x 14 cm
Ink autograph on reverse: 'To my dearest Count Sergei Dmitrievich as a memento from an old friend. K. Pobedonostsev 24 April 1902' / Provenance: in 1941, State Museum of Ethnography of the Peoples of the USSR / Inv. no. ERFt-23515 / G.M.

87
Sergei Lvovich and Lev Sergeyevich Levitski
PORTRAIT VAN TSAR ALEXANDER III, 1890s
Photogravure
59.5 x 46.0 cm; 61 x 48 cm / Inscription, printed, below: 'Photogravure after photo by Levitski. – His Imperial Highness Tsar Alexander Alexandrovich Monarch of All Russia. – Published by the photographer to their Imperial Highnesses Levitski. – Property of the publisher' / Provenance: 1965, Scientific Library of the State Hermitage Museum / Inv. no. ERFt-30158 / N.A.

88
Sergei Lvovich and Lev Sergeyevich Levitski
PORTRAIT OF TSAR NICHOLAS II, 1890s
Photogravure
53.5 x 44.5 cm; 55.3 x 46 cm / Inscription, printed, below: 'Photogravure after photo by Levitski – His Imperial Highness Tsar Nikolai Alexandrovich Monarch of All Russia. Published by the photographer to their Imperial Highnesses Levitski. – Property of the publisher' / Provenance: 1965, Scientific Library of the State Hermitage Museum / Inv. no. ERFt-30159 / N.A.

89
B.P. Mishchenko *(late 19th/early 20th century)*
PORTRAIT OF GRAND DUKE GEORGI ALEXANDROVICH,
1890s
Photo in passe-partout
14.5 x 11 cm; 16 x 11 cm / Mark on reverse: photo studio. Inscription, printed on photo, below: 'B. Mishchenko in Tiflis' / Provenance: 1941, State Museum of Ethnography of the Peoples of the USSR, previously of the State Museum Fund / Inv. no. ERFt-26887 / T.P.

90
Unknown Photographer *(late 19th/early 20th century)*
PORTRAIT OF PYOTR STOLYPIN, 1900s
Photo
13.8 x 8.5 cm / Inscription on photo, below: 'Chairman of the Ministerial Council and Minister of the Interior P.A. Stolypin' / Provenance: 1941, State Museum of Ethnography of the Peoples of the USSR / Inv. no. ERFT-26857 / G.M.

91
Boissonas and Eggler Studio
PORTRAIT OF TSAREVICH ALEXEI NIKOLAYEVICH,
1910–1912
Photo in passe-partout
19.4 x 9.7 cm; 24.7 x 12.8 cm / Mark: cropped print of photo studio's mark.
Ink autograph on passe-partout, below: 'Alexei' / Provenance: 1941,
State Museum Fund / Inv. no. ERFt-30111 / G.M.

92
Unknown Photographer *(19th century)*
PORTRAIT OF VLADIMIR FREDERICKS, *1887*
Albumin print
16 x 20 cm; 22 x 24 cm / Ink inscription on reverse: 'Summer at Siverskaya
1887'; in pencil: 'Court Minister – Baron Fredericks' / Provenance: 1941,
State Museum of Ethnography of the Peoples of the USSR / Inv. no.
ERFt-18545 / G.M.

93
Unknown Photographer *(19th century)*
MEETING THE PRESIDENT OF THE FRENCH REPUBLIC
FÉLIX FAURE AT THE ENGLISH QUAY IN ST PETERSBURG,
1898
Albumin print
16 x 22 cm / Provenance: 1941, State Museum of Ethnography of the
Peoples of the USSR / Inv. no. 18849 / G.M.

94
Yosif Adolfovich Otsup *(late 19th/early 20th century)*
PORTRAIT OF SERGEI WITTE, *c. 1915*
Silver bromide print
20 x 16 cm / Ink inscription, right: 'The last photo of Witte' / Provenance:
1941, State Museum of Ethnography of the Peoples of the USSR / Inv. no.
ERFt-18523 / G.M.

95
P.P. Schaumann
PORTRAIT OF JOHANNES VAN KRONSTADT, *1894*
Albumin print
14 x 10 cm / Ink inscription on passe-partout: '25 Jan. 1894. archpriest
Johannes van Kronstadt' / Provenance: 1941, State Museum of Ethnography
of the Peoples of the USSR / Inv. no. ERFt-18608 / G.M.

SCULPTURE

96
Mark Matveyevich Antokolski *(1843–1902)*
PORTRAIT OF ALEXANDER POLOVTSOV, *1887*
Bust, marble
72 x 53 x 37 cm / Inscription on reverse: 'Antokolsky' / Provenance: 1919,
from of Baron Alfred Stieglitz's School of Technical Drawing. / Inv. no.
ERFt-204 / L.T.

97
Leopold Adolfovich Bernstamm
(Leopold Berngard Leib-Ber) *(1859–1939)*
SÈVRES PORCELAIN FACTORY

PORTRAIT OF TSAR NICHOLAS II, *1891*
Bust, porcelain, double-fired
46 x 38 x 21 cm / Marks: on reverse, below left on shoulder: factory; below
right on cloak: artist / Provenance: 1920s, State Museum Fund, previously
of the Winter Palace / Inv. no. ERSk-236 / L.T.

ENGRAVING

98
ONE-SIDED PLAQUETTE WITH PORTRAIT OF
TSAR NICHOLAS II AND TSAREVICH ALEXEI, *1906*
Copper, engraving
62 x 91 mm / Provenance: 1907, Aves-Münze company / Inv. no. RM-7130 /
E.S.

99
ONE-SIDED PLAQUETTE WITH PORTRAIT OF
TSARINA ALEXANDRA FYODOROVNA, *1906*
Copper, engraving
62 x 91 mm / Provenance: 1901, Aves-Münze company / Inv. no. RM-7131 /
E.S.

ORDERS AND MEDALS

100
Anton Fyodorovich Vashutinski *(1858–1935)*
MEDAL COMMEMORATING THE WEDDING OF
TSAR NICHOLAS II AND PRINCESS ALICE OF HESSE
ON 14 NOVEMBER 1894, *1896*
Silver, engraving
Ø 70 mm / Obverse image: busts of the young couple; reverse: coronation
scene. Foremost inscription on field of medal: '14 November 1894'; border
inscription: 'Commemorating the Wedding of Tsar Nicholas II and
Princess Alice of Hesse'; reverse, below right: 'V' / Provenance: 1896,
from St Petersburg Mint / Inv. no. RM-4605 / E.S.

101
Anton Fyodorovich Vashutinski *(1858–1935)*
LARGE CORONATION MEDAL OF TSAR NICHOLAS II, *1896*
Silver, engraving
Ø 10 mm / Obverse image: profiles of Nicholas II and Alexandra Fyodorovna;
reverse: city coat of arms. Inscription below left, in small letters: 'A. Vas-ki';
border inscription: 'Tsar Nicholas II Tsarina Alexandra Fyodorovna.
Crowned in Moscow in 1896'; from above along the edge: 'God is with us' /
Provenance: 1896, from St Petersburg Mint / Inv. no. RM-4651 / E.S.

102
CHAIN OF THE ORDER OF ST ANDREAS, *1856*
Gold, enamel, punching, casting, hot enamel, engraving,
montage
55 x 1060 mm / Marks: studio, St Petersburg 1856, double-headed eagle
(symbol of court supplier), assayer's mark 72 / Provenance: date unknown,
State Museum Fund / Inv. no. Vz-1384 / M.D.

103
EMBLEM OF THE ORDER OF ST ANDREAS, *1861*
Gold, enamel, punching, engraving, chasing, hot enamel, montage
63 x 82 mm / Marks: St Petersburg in circle; studio, double-headed eagle (symbol of court supplier); on the eye of the crown: assayer's mark 56 / Provenance: 1863, Order Chapel, from a museum collection of all Russian orders / Inv. no. Vz-1393 / M.D.

104
STAR OF THE ORDER OF ST ANDREAS, *1830–1870*
Silver, gold, enamel, punching, chasing, engraving, gilt, enamel, montage
82 x 83 mm / Marks: St Petersburg in circle, studio, assayer's mark 84 / Provenance: date unknown, State Museum Fund / Inv. no. Vz-1320 / M.D.

105
EMBLEM OF THE ORDER OF ST ALEXANDER NEVSKI,
late 19th century
Gold, enamel, punching, chasing, engraving, painting on enamel, enamelling, montage
48 x 73 mm (with eye and ring) / Marks: St Petersburg in oval, assayer's mark 56 / Provenance: 1938, former Gallery of Valuables at the Winter Palace / Inv. no. Vz-318 / M.D.

106
STAR OF THE ORDER OF ST ALEXANDER NEVSKI, *1830–1870*
Silver, enamel, gilt, punching, chasing, casting, gilt, enamelling, montage
88 x 88 mm / Marks: studio, St Petersburg in circle, assayer's mark 84 / Provenance: 1961, State Depot of Valuables of the Ministry of Finance of the USSR / Inv. no. IO-1434 / M.D.

107
STAR OF THE MILITARY ORDER OF ST GEORGE, *1830–1870*
Silver, enamel, punching, chasing, gilt, enamelling, montage
87 x 87 mm / Marks: studio, St Petersburg in circle, assayer's mark 84 / Provenance: 1951, State Depot of Valuables of the Ministry of Finance of the USSR / Inv. no. IO-1436 / M.D.

108
STAR OF THE MILITARY ORDER OF ST GEORGE,
2ND AND 3RD CLASS, *1850–1900*
Gold, enamel, punching, enamelling, painting on enamel, montage
47 x 51 mm (with eye) / Provenance: date unknown, State Museum Fund / Inv. no. Vz-1130 / M.D.

109
EMBLEM OF THE ORDER OF THE APOSTOLIC PRINCE
ST VLADIMIR, 2ND CLASS, *1850–1860*
Gold, enamel, punching, enamelling, painting on enamel, montage
45 x 68 mm (with eye and ring) / Marks: assayer's mark 56, date mark 18 / Provenance: 1967, Acquisitions Committee of the State Hermitage Museum / Inv. no. Vz-1210 / M.D.

110
STAR OF THE ORDER OF THE APOSTOLIC PRINCE
ST VLADIMIR, *1850–1900*
Silver, enamel, punching, chasing, enamelling, gilt, montage
87 x 87 mm / Marks: studio, St Petersburg in circle, assayer's mark 84 / Provenance: 1951, State Depot of Valuables of the Ministry of Finance of the USSR / Inv. no. IO-1437 / M.D.

111
EMBLEM OF THE ORDER OF ST ANNA,
2ND CLASS WITH RIBBON, *1850–1900*
Gold, enamel, punching, enamelling, painting on enamel, montage
44 x 68 mm (with eye and ring) / Marks: St Petersburg in oval, assayer's mark 56, under enamel: double-headed eagle (symbol of court supplier) / Provenance: 1938, former Gallery of Valuables at the Winter Palace / Inv. no. Vz-483 / M.D.

112
STAR OF THE ORDER OF ST ANNA, *1830–1870*
Silver, enamel, gilt, punching, chasing, casting, enamelling, montage
89 x 89 mm / Marks: St Petersburg, studio, double-headed eagle (symbol of court supplier), assayer's mark 84 / Provenance: date unknown, State Museum Fund / Inv. no. IO-24364 / M.D.

113
ORDER BATON, *after 1915*
BELONGING TO TSAR NICHOLAS II
Gold, silver, bronze, enamel, punching, chasing, engraving, hot enamel, montage
170 x 97 mm / Provenance: 1938, former Gallery of Valuables at the Winter Palace / Inv. no. Vz-319

The baton comprises ten decorations: four orders and six medals

1. Emblem of the Order of St Vladimir, 4th Class
 Gold, enamel / *34 x 45 mm*
2. France. Emblem of the Military Cross with Swords, instituted 8 April 1915
 Bronze / *36 x 46 mm*
3. Medal 'Commemorating the Coronation of Tsar Alexander III', struck 4 May 1884
 Gilt bronze / *Ø 29 mm*
4. Medal 'Commemorating the Reign of Alexander III', struck 17 March 1896
 Silver / *Ø 27 mm*
5. Medal 'Commemorating the Bicentenary of the Victory at Poltava', struck 27 June 1909
 Gilt bronze / *Ø 27 mm*
6. Medal 'Commemorating Centenary of the Patriotic War of 1812', struck 26 August 1912
 Gilt bronze / *Ø 27 mm*
7. Medal 'Commemorating Tercentenary of the Rule of the House of Romanov', struck 12 March 1913
 Gilt bronze / *Ø 28 mm / This is the reverse of the medal, the obverse shows a portrait of Nicholas II.*

8. Medal 'Commemorating the Bicentenary of the
Battle of Gangut', struck 12 June 1914
Gilt bronze / Ø 27 mm
9. Denmark. Emblem of the Order of Daneborg
(a Danish banner), instituted in 1219, revived in 1617
Silver / 27 x 57 mm
10. Greece. Emblem of the Order of the Saviour,
instituted in 1833
Gold, silver, enamel / 33 x 55 mm / M.D.

ARMS

114
Izhevsk Arms Factory
SET OF THREE MODEL FIREARMS, 1897
Polished and browned steel (barrels and other metal
sections), polished wood (stocks and butts), case upholstered
with clear leather and inside with silk and velvet
*1) Total length 30 cm, barrel 17 cm; 2) Total length 32 cm, barrel 19 cm;
3) Total length 30 cm, barrel 17.5 cm / Mark: engraved on powder chamber
on barrels: 'Izhevsk Arms Factory 1897'. Monogram below crown, gilt,
inscribed: 'N II'. Inscription on outside of case, in gold print: 'For His
Imperial Highness Tsar Nikolai Alexandrovich, Our Father and Benefactor.
The loyal subjects, armourers of Izhevsk, commemorating the manufacture
at the factories of Izhevsk of half a million 3-barrel rifles. March 1897' /
Provenance: unknown. Since 1936 among the documents of the State
Hermitage Museum / Inv. no. ZO-5479, ZO-5479a, ZO-5481 / J.M.*

DECORATIVE ART

115
Iosif Abramovich Marshak Factory, Kiev
PRESENTATION DISH WITH SALT CELLAR,
COMMEMORATING THE CORONATION OF
TSAR NICHOLAS II, 1896
Labradorite, silver, casting, chasing, gilt, carving
*Dish 54.5 x 54.5 x 5 cm; salt cellar 16.5 x 14 x 14 cm / Marks: factory,
unknown assayer, city of Kiev. Monogram 'N II A, August 1896'.
Inscription on dish: 'From the loyal nobles of Kiev'; 'Made by Iosif
Marshak. In Kiev. Labrador made by V.V. Korchakov-Sivitski'; on salt
cellar: 'Made by Iosif Marshak in Kiev' / Provenance: date unknown,
State Museum of Ethnography of the Peoples of the USSR, previously
of the Diamond Room in the Winter Palace / Inv. no. ERO-5428,
ERO-3922a,b / L.Z., K.O.*

116
Studio of Nikolai Fyodorovich Strulev, Moscow
PRESENTATION DISH COMMEMORATING THE
TERCENTENARY OF THE HOUSE OF ROMANOV,
PRESENTED BY THE PEOPLE OF THE CITY OF VLADIMIR,
1913
Wood, silver, almandites, chrysolites; enamel, casting,
chasing, painting on enamel
52.5 x 53.5 x 5 cm / Marks: studio, Moscow assay office, assayer's mark 84.

*Inscription on dish: 'To His Imperial Highness Tsar Nikolai Alexandrovich
from the old capital city Vladimir 16 May 1913' / Provenance: 1956,
previously of Alexander Palace, Tsarskoye Selo / Inv. no. ERO-8679 /
L.Z., K.O. /*

117
Master Axel Hedlund, St Petersburg
COMMUNION SET FROM THE FIELD CHURCH OF
TSAR ALEXANDER I, 1812
Silver, gilt, enamel, paper, casting, carving, engraving
*The set is enclosed in a wooden box (38.3 x 70.4 x 52.1 cm) and comprises: /
Chalice 32.4 x 13 x 17 cm; altar cross 36.3 x 22.5 cm; Gospel 5.3 x 20.4 x 17 cm;
star 14.7 x 10.4 cm; paten 9 x 22.2 x 22.2 cm; basin for washing hands Ø 31.7 cm;
plates Ø 13.9 cm; small jug 3.7 x 14.4 x 9.3 cm; artoforion 12.3 x 16.5 x 10.3 cm;
flagon 3.4 x 2.1 cm; spoons 25.4 x 4.6; lances 1) 19.9 x 2.7 cm; 2) 13.8 x 1.7 cm
/ Marks: 'Hedlund, AN' (master); 'AY' (assayer Alexander Yashinov);
city assay mark of St Petersburg; '84' (silver mark) / Provenance: date
unknown, Central Depot of the City's Museum Palaces, previously of
Alexander Palace, Tsarskoye Selo / Inv. no. ERO 8765-8778 / L.Z., K.O.*

118
P.A. Ovchinnikov Factory, Moscow
PRESENTATION SALT CELLAR WITH LID, 1890
Silver, gilt, casting, carving, chasing
*18.5 x 15 x 15 cm / Marks: below double-headed eagle: factory; city of
Moscow assayer; silver mark 84. Inscription: 'To His Imperial Highness
the Heir to the Throne Tsarevich Grand Duke Nikolai Alexandrovich from
the shareholders association of the Pashkov family's Beloretski Ironworks
Factories 1891' / Provenance: 1941, State Museum of Ethnography of the
Peoples of the USSR, previously of the Winter Palace collection / Inv. no.
ERO-4998a,b / L.Z., K.O.*

PRODUCTS MADE BY
FABERGÉ, ST PETERSBURG

Fabergé is one of the world's most famous jewellery makers.
In 1842 the founder, Gustav Fabergé (1814–1893), opened a
jewellery studio in St Petersburg and a shop on Bolshaya
Morskaya street. Carl Fabergé (1846–1920) expanded his
father's business considerably by combining his St Petersburg
branch with the finest jewellers of the capital: Erik Kolin,
August Holmström, Michail Perchin, Henrik Wigström, Yuli
Rappoport.
In 1885 Carl Fabergé was appointed Supplier to the Court of
His Imperial Highness and in 1887 a branch was opened in
Moscow, as well as shops in Kiev, Odessa and London.
Carl Fabergé was the imperial family's favourite jeweller. The
company received commissions for diplomatic gifts, presents
to mark the birth of children to the tsar's family and the
families of the grand dukes, and expensive wedding gifts.
Fabergé items accompanied the House of Romanov throughout
their lives, from the cradle to the grave.
Jewels by Fabergé were popular showpieces at national and
international exhibitions. At the Paris Exposition of 1900
Fabergé received a Grand-Prix and the Légion d'Honneur for
a miniature copy of the imperial regalia. They remained in
Russia until 1917.

119

Master Michail Yevlampievich Perchin
MOURNING CROSS WITH PHOTOGRAPHIC PORTRAIT OF
TSAR ALEXANDER III, c. 1894
Gold, enamel, photo
*4.6 x 2.1 cm / Marks: firm, master, St Petersburg, assayer's mark 56.
Inscription on reverse: '20-10-1894' (date of tsar's death) / Provenance: 1935,
Catharina Palace, Tsarskoye Selo / Inv. no. E-15595 / O.K.*

120

Master Johann Viktor Aarne
FRAME WITH PHOTO OF GRAND DUCHESS
IRINA ALEXANDROVNA, 1890s
Wood, gilt, enamel, photo
*16.7 x 5.8 x 5.2 cm / Marks: master, firm, St Petersburg last quarter 19th
century, assayer's mark 88, ind.no. 55942 / Provenance: 1941, State Museum
of Ethnography of the Peoples of the USSR, previously of the Palace of
Grand Duchess Xenia Alexandrovna, St Petersburg / Inv. no. ERO-6751 /
L.Z., K.O.*

121

Master Michail Yevlampievich Perchin
FRAME WITH PHOTO OF TSARINA ALEXANDRA
FYODOROVNA AND HER DAUGHTER TATYANA, 1890s
Silver, gilt, enamel, bone, photo
*14.3 x 7 x 1 cm / Marks: master, firm, St Petersburg last quarter 19th
century, assayer's mark 88, ind. no. 58606. Inscription on reverse:
'From Niki and Alix 25 m. 1898' / Provenance: 1941, State Museum
of Ethnography of the Peoples of the USSR, previously of the Palace
of Grand Duchess Xenia Alexandrovna, St Petersburg / Inv. no.
ERO-6761 / L.Z, K.O.*

122

Master Michail Yevlampievich Perchin
PERFUME BOTTLE, 1900s
Coloured gold, enamel, rose diamonds, carving
*4.5 x 2 x 1 cm / Marks: master, firm, St Petersburg assay office with
initials of the inspector, assayer's mark 56 / Provenance: 1982, Acquisitions
Committee of the State Hermitage Museum / Inv. no. ERO-9328 /
L.Z, K.O.*

123

Master Henrik Emanuel Wigström
BOX, 1900s
Agate, rose diamonds, ruby, gold, casting, chasing
*4.5 x 4.7 x 4.7 cm / Marks: master, firm, St Petersburg assay office
1896–1903 with initials of the inspector, assayer's mark 56 / Provenance:
1982, Acquisitions Committee of the State Hermitage Museum / Inv. no.
ERO-9322 / L.Z., K.O.*

124

Master Henrik Emanuel Wigström
PERFUME BOTTLE, 1900s
Silver, gold, dendrite, rose diamonds, enamel on a carved
background
*2.5 x 3.0 x 1.0 cm / Marks: master, St Petersburg assay office 1896–1903
with initials of the inspector, assayer's mark 5688 / Provenance: 1982,
Acquisitions Committee of the State Hermitage Museum / Inv. no.
ERO-9333 / L.Z., K.O.*

125

Master Henrik Emanuel Wigström
TABLE CLOCK, 1910s
Silver, bone, steel, casting, enamel on carved background,
carving
*9.2 x 9.2 x 2.7 cm / Marks: master, firm, St Petersburg assay office
1907–1917, assayer's mark 88 / Provenance: 1982, Acquisitions Committee
of the State Hermitage Museum / Inv. no. ERO-9334 / L.Z., K.O.*

126

Master Johann Viktor Aarne
MECHANICAL TABLE BELL, 1900s
Silver, moonstone, enamel, gilt, casting, chasing, carving
*3.9 x 6 x 6 cm / Marks: master, firm, St Petersburg assay office with initials
of the inspector, assayer's mark 84 / Provenance: 1979, Acquisitions Committee
of the State Hermitage Museum / Inv. no. ERO-9266 / L.Z., K.O.*

127

Master Fyodor Alexeyevich Afanashev
INK POT, 1890s
Silver, gold, nephrite, ruby, diamonds, enamel, casting,
carving, engraving
*8 x 6.7 x 6.7 cm / Marks: master, firm, St Petersburg assay office 1896–1903,
assayer's mark 88 / Provenance: 1986, Acquisitions Committee of the State
Hermitage Museum / Inv. no. ERO-9498 / L.Z, K.O.*

128

Master Yuli Alexandrovich Rappoport
ASHTRAY IN THE SHAPE OF FISH, 1890s
Silver, casting, chasing, gilt
*8.6 x 14.9 x 5.9 cm / Marks: master, firm, St Petersburg last quarter 19th
century, assayer's mark 88 / Provenance: 1966, Acquisitions Committee of
the State Hermitage Museum / Inv. no. ERO-8962 / L.Z., K.O.*

129

Masters Yuli Alexandrovich Rappoport and
August Vilhelm Holmström
MINIATURE COPY OF THE SYMBOLS OF IMPERIAL POWER,
1899–1900
Gold, silver, platinum, diamonds, spinel, pearls, sapphires,
velvet, pink quartzite
*Total height with base 42.5 cm; large crown 7.3 x 5.4 cm; small crown
3.8 x 2.9 cm; orb 3.8 x 4.4 cm; sceptre 15.8 cm / Marks: firm, Master Rappoport,
St Petersburg 1899–1908, assayer's mark 88. Inscription on base of large
crown: 'C. Fabergé' / Provenance: 1901, after the Paris Exposition of 1900 /
Inv. no. E-4745 / O.K.*

130

Unknown Master
SCOOP IN THE SHAPE OF AN ELEPHANT'S HEAD,
early 20th century
Obsidian, rose quartz, carving
*4.5 x 9.1 x 5.5 cm / Provenance: 1951, State Depot of Valuables of the
Ministry of Finance of the USSR / Inv. no. E-17154 / L.J.*

131

Master Michail Yevlampievich Perchin
BOX IN THE SHAPE OF A SHELL, *late 19th century*
Nephrite, gold, rose quartz, rubies, carving, chasing

6.3 x 6.1 x 3.0 cm / Marks: St Petersburg, firm; master, assayer's mark 56 / Provenance: 1951, State Depot of Valuables of the Ministry of Finance of the USSR / Inv. no. E-17151 / L.J.

132
Master Michail Yevlampievich Perchin
COMPASS, early 20th century
Gold, rose quartz, enamel, chasing, guilloching
Height 3.7 cm, Ø 3.7 cm / Marks: firm, master, assayer's mark 56 / Provenance: 1951, State Depot of Valuables of the Ministry of Finance of the USSR / Inv. no. E-17145 / L.J.

133
Master Michail Yevlampievich Perchin
SHOW-BOX, 1900s
Agate, gold, casting, chasing, engraving
7.5 x 4.9 x 7.0 cm / Marks: St Petersburg, firm, master, assayer's mark 56 / Provenance: 1948, Acquisitions Committee of the State Hermitage Museum / Inv. no. E-15603 / L.J.

134
Master Yuli Alexandrovich Rappoport
FLOWER VASE, 1890s
Smoke stone, silver, carving, casting, chasing, gilt
Height 37.0 cm / Marks: St Petersburg, firm, master / Provenance: 1931, Winter Palace collection / Inv. no. E-17576 / L.J.

135
Unknown Master
BLUEBERRY TWIG IN A VASE, 1880–1890
Gold, nephrite, azure, rock crystal, casting, polishing, carving, chasing
Height 14.2 cm / Provenance: 1919, A.K. Rudanovski collection, St Petersburg / Inv. no. E-14893 / L.J.

136
Master Michail Yevlampievich Perchin
GOLD BOX WITH ENAMEL AND JEWELS, 1890–1900
Gold, enamel, diamonds, rubies, sapphire, polishing
2.8 x 2.3 x 2.2 cm / Marks: firm, master, St Petersburg, assayer's mark 56, N 47449 / Provenance: 1908, transferred from the collection of Grand Duke Alexei Alexandrovich / Inv. no. E-307 / L.J.

137
Unknown Master
TABLE ORNAMENT IN THE SHAPE OF A LIZARD, 1901
Silver, casting, chasing, engraving
23.3 x 9.5 cm / Marks: St Petersburg, firm, assayer's mark 84. Inscription on reverse: '5 September, Skittles Festival 1901' / Provenance: 1987, Acquisitions Committee of the State Hermitage Museum / Inv. no. E-17851 / L.J.

138
Master Erik August Kollin
DISH WITH TWO HANDLES, 1880–1890
Agate, almandines, silver, carving, chasing, gilt, blacking
6.0 x 11.7 x 6.1 cm / Marks: St Petersburg, firm, master, assayer's mark 84 / Provenance: 1984, Acquisitions Committee of the State Hermitage Museum Inv. no. E-17797 Vs 3750 / L.J.

139
Ivan Savelyevich Britsyn Studio, St Petersburg
TABLE CLOCK, 1910–1920
Silver, bone, enamel, casting, guilloching, engraving
9.3 x 9.4 x 2 cm / Marks: studio, St Petersburg assay office 1908–1917, assayer's mark 88 / Provenance: 1988, Acquisitions Committee of the State Hermitage Museum / Inv. no. ERO-9575 / L.Z., K.O.

140
Master Henrik Emanuel Wigström
STAMP, 1898–1899
Nephrite, carnelian, gold, carving, chasing
Height 8.3 cm, Ø 2.8 cm / Marks: St Petersburg, master, mark 56, of the assayer (1898–1899) / Provenance: 1951, State Depot of Valuables of the Ministry of Finance of the USSR / Inv. no. E-17148 / L.J.

141
Master Michail Yevlampievich Perchin
FRAME WITH MINIATURE PORTRAIT IN SLEEVE, 1899–1900
Gold, silver, pearls, ivory, gouache, enamel, chasing, guilloching
9.5 x 7.9 cm / Marks: St Petersburg, master, assayer's mark 56. Signature on miniature: 'Th. Zashe 99'. Inscription on reverse of miniature: 'Charle Goluchovski 1899' / Provenance: 1951, State Depot of Valuables of the Ministry of Finance of the USSR / Inv. no. E-16958 / L.J.

142
Master Michail Yevlampievich Perchin
ELECTRIC BELL, 1900–1910
Silver, copper alloys, moonstone, enamel, silk, gilt, guilloching, chasing
Height 5.0 cm, Ø 3.0 cm / Marks: St Petersburg, master, assayer's mark 88 / Provenance: 1922, Winter Palace / Inv. no. E-13496 / L.J.

143
Master Friedrich Kuchli
LORGNETTE WITH CHAIN, 1880–1890
Gold, sapphires, rubies, diamonds, pearls, glass
Length with chain 44.0 cm / Marks: master (in oval), St Petersburg, assayer's mark 56 / Provenance: 1951, State Depot of Valuables of the Ministry of Finance of the USSR / Inv. no. E-17166 / L.J.

144
Master Pierre-Étienne Théremin, St Petersburg
TOBACCO POT WITH MONOGRAM OF TSAR ALEXANDER I, 1800–1810
Gold, enamel, diamonds, silver
1.2 x 9.0 x 5.5 cm / Marks: master, assayer, St Petersburg 1800 / Provenance: 1908, bequeathed by Grand Duke Alexei Alexandrovich / Inv. no. E-309 / O.K.

145
P.I. Olovyanishnikov and Sons, Moscow
GOSPEL, 1911
Paper, print, velvet, silver, amethysts, gilt, filigree
6.2 x 19 x 15 cm / Marks: factory, Moscow assay office 1908–1917, assayer's mark 84 / Provenance: 1956, previously of Alexander Palace, Tsarskoye Selo / Inv. no. ERO-8827 / L.Z., K.O.

146
P.I. Olovyanishnikov and Sons, Moscow
CROSS IN ENAMEL-SILVER FRAME WITH
RHODOLITE HANDLE, *1912*
Wood, tempera, mica, aquamarine, amethysts, rhodolite,
silver, enamel, filigree, casting, carving
*38 x 18.3 x 2 cm / Marks: factory, Moscow assay office 1908–1917, assayer's
mark 84. Inscription: 'Gift of the Bessarabian clergy to the episcopal
cathedral of Kishinyov in 1912 commemorating the centenary of the
unification of Bessarabia and Russia' / Provenance: 1951, State Depot of
Valuables of the Ministry of Finance of the USSR / Inv. no. ERO-7729 /
L.Z., K.O.*

147
A.N. Sokolov Studio, St Petersburg
BULBOUS CENSER IN 17TH-CENTURY STYLE, *1900–1910*
Silver, gilt, casting, filigree, incense grains
*23.5 x 9.5 x 9.5 cm, length of chain 66 cm / Marks: master, St Petersburg
assay office 1896–1903, inspector, assayer's mark 84 / Provenance: 1941,
State Museum of Ethnography of the Peoples of the USSR / Inv. no.
ERO-5666 / L.Z., K.O.*

148
Master E. Bastanier, France *(2nd half 19th century)*
SPEECH IN LEATHER ETUI WITH GOLD MONOGRAM
UNDER THE IMPERIAL CROWN, *1896*
Leather, paper, copper, gold, diamonds, enamel, rubies,
material, chasing, ornamental imprints, painting
*45 x 32.5 cm / Inscription, below: 'E. Bastanier, 1896' / Provenance:
original collection of the Winter Palace / Inv. no. E-9703*

PORCELAIN

149
Königliche Porzellan Manufaktur, Berlin
TABLE AND DESSERT SERVICE WITH TABLE DECORATION,
1894
Porcelain, painting over the glaze, gilt
*Marks on each item: sceptre (dark-blue under the glaze), orb with letters
'KPM' (in red over the glaze) / Provenance: 1922, Service Room of the
State Hermitage Museum*

GRAVY BOAT
Height 9.5 cm, length 25.0 cm / Inv. no. ZF-19911
OVAL BOWL WITH LID
Height 23.8 cm, length 42.2 cm / Inv. no. ZF-19930a,b
UNDERPLATE FOR OVAL BOWL
Length 46.0 cm / Inv. no. ZF-19934
FRUIT BOWL
Height 18.0 cm, Ø 23.1 cm / Inv. no. ZF-19938
CANDELABRUM
Height 63.0 cm / Inv. no. ZF-24832 / L.L.

150
Imperial Porcelain Factory, St Petersburg
EASTER EGG WITH GILT MONOGRAM 'N II'
UNDER RUSSIAN TSARIST CROWN ON A
DARK-RED GLAZE BACKGROUND, *1894–1911*
Porcelain, coloured glaze, fired at high temperature,
flambé, etching, gilt, silver plate
*9.2 x 7.4 cm / Provenance: 1941, State Museum of Ethnography of the Peoples
of the USSR, previously of the Winter Palace / Inv. no. ERF-5493 / T.K.*

151
Imperial Porcelain Factory, St Petersburg
EASTER EGG WITH GILT MONOGRAM 'AΩ'
UNDER RUSSIAN TSARIST CROWN ON A
COBALT BACKGROUND, *1894–1917*
Porcelain, cobalt cover under the glaze, etching, tinted gilt
*8.9 x 7.1 cm / Provenance: 1941, State Museum of Ethnography of the
Peoples of the USSR, previously of the Winter Palace / Inv. no. ERF-5494
/ T.K.*

GLASS

152
Imperial Glass Factory, St Petersburg
TULIP VASE, *1898*
After a drawing by K. Krasovski (?)
Double layered (pale and blueish turquoise) crystal, carving,
grinding, polishing
*30 x 20 x 20 cm / Mark, carved on base: 'N II' below crown. Inscription:
'1898' / Provenance: 1931, private apartment of Alexandra Fyodorovna at
the Winter Palace / Inv. no. ERS-2430 / T.M.*

153
Master A. Zotov, Imperial Glass Factory, St Petersburg
IRIS VASE, *1900*
After a drawing by K. Krasovski (?)
Double layered (matt lilac and purple lilac) crystal, carving,
grinding, polishing
*30.5 x 19.5 x 19.5 cm / Mark, carved on base: 'N II' below crown.
Inscription: '1900' / Provenance: 1931, private apartment of Alexandra
Fyodorovna at the Winter Palace / Inv. no. ERS-2432 / T.M.*

METAL DECORATIVE OBJECTS

154
Erven Vasili Stepanovich Batashov Samovar Factory, Tula
SAMOVAR WITH MONOGRAM:
'N II A' BELOW TSARIST CROWN, *1896*
Copper, hammering, gilt, engraving, carving, ivory
*Samovar: 54 x 40 x 43 cm; pipe: 28 x 14 x 10 cm / Mark on lid: factory.
2 medals, op lid, from the Russian Industrial Exhibitions of 1870 and 1882.
recessed monogram on body: 'N II A'. Inscription: '1896' / Provenance:
1941, State Museum of Ethnography of the Peoples of the USSR / Inv. no.
ERM-2275a-g*

ACCOMPANYING TRAY WITH INCISED FOLIATE
ORNAMENTATION ALONG THE BORDER, *late 19th century*
Copper, forging, carving, gilt, cloth
*59 x 37.5 cm / Provenance: 1982, Acquisitions Committee of the State
Hermitage Museum / Inv. no. ERM-8529 / M.K.*

WOOD AND
VARIOUS MATERIALS

155
Lukutin Family Factory, near Moscow
EASTER EGG, *2nd half 19th century*
Papier-maché, oil paint, gilt, painting, lacquer
*11.5 x 7.5 x 7.5 cm / Inscription inside one half: 'Christ has risen' /
Provenance: 1941, State Museum of Ethnography of the Peoples of the
USSR, previously of Anichkov Palace / Inv. no. ERRz-109a,b / I.O.*

156
Lukutin Family Factory, near Moscow
EASTER EGG, *2nd half 19th century*
Papier-maché, oil paint, painting, gilt, lacquer
*16 x 10.5 x 10.5 cm / Inscription inside one half: 'From the Old Believers of
Moscow who accept the Priesthood' / Provenance: 1941, State Museum of
Ethnography of the Peoples of the USSR / Inv. no. ERRz-125a,b / I.O.*

TOYS

157
MONKEY, *late 19th century*
Fabric, plush, mastic; cloth (shirt and frock)
featuring a floral motif
*35 x 27 cm / Provenance: date unknown, Alexander Palace,
Tsarskoye Selo / Inv. no. ERRz-2707 / I.O.*

158
WHITE PLUSH BEA, *1900–1910*
Wool plush, cloth, glass
*Height 73 cm / Provenance: 1941, State Museum of Ethnography of
the Peoples of the USSR, previously of Alexander Palace, Tsarskoye Selo /
Inv. no. ERT-14794 / J.P.*

159
PLUSH DOG, *1900–1910*
Wool plush, cloth, glass
*33 x 47 cm / Provenance: 1941, State Museum of Ethnography of the
Peoples of the USSR, previously of Alexander Palace, Tsarskoye Selo /
Inv. no. ERT-14795 / J.P.*

160
PLUSH CAT, *1900–1910*
Wool plush, cloth, glass, metal
*27 x 30.5 cm / Provenance: 1941, State Museum of Ethnography of the
Peoples of the USSR, previously of Alexander Palace, Tsarskoye Selo /
Inv. no. ERT-14796 / J.P*

161
'SOTKA'(HUNDRED) GAME, *late 19th century*
Card, paper, print
*41 x 27 cm / Provenance: date unknown, Alexander Palace,
Tsarskoye Selo / Inv. no. ERRz-1252 / I.O.*

162
'GEOGRAPHIC LOTTO' GAME, *late 19th century*
Card, paper, print
*35 x 21 cm / Provenance: date unknown, Alexander Palace, Tsarskoye Selo /
Inv. no. ERRz-2217 / I.O.*

163
MODEL OF A PRINTING PRESS, *1904–1917*
Steel, wood, lead, velvet, lacquer, polishing
*45.5 x 55.5 x 39 cm / Inscription on base: 'For His Imperial Highness the
Heir to the Throne Tsarevich Alexei Nikolayevich'; on top beam of press
frame: 'Made by the prisoners of the 1st prison of Nizhni-Novgorod' /
Provenance: unknown / Inv. no. ONPTch-20 / G.J.*

COSTUMES

164
FESTIVE COSTUME OF TSAREVICH ALEXEI NIKOLAYEVICH,
c.1909
Velvet, taffeta, silver, copper, pearls, wire, embroidery,
punching
*Length of back of jacket 35 cm; trouser length 47 cm / Provenance: 1941,
State Museum of Ethnography of the Peoples of the USSR, previously
of Alexander Palace, Tsarskoye Selo / Inv. no. ERT-12797, 12798 / J.P.*

165
BABY FROCK OF TSAREVICH ALEXEI NIKOLAYEVICH,
1900–1910
Mousseline, silk, lace
*55 x 137 cm / Provenance: 1941, State Museum of Ethnography of the
Peoples of the USSR, previously of Alexander Palace, Tsarskoye Selo /
Inv. no. ERT-13589 / J.P*

166
DRESSING GOWN OF TSAREVICH ALEXEI NIKOLAYEVICH,
1900–1910
Cashmere, silk
*72 x 209 cm / Provenance: 1941, State Museum of Ethnography of the
Peoples of the USSR, previously of Alexander Palace, Tsarskoye Selo /
Inv. no. ERT-13614 / J.P.*

167
CAP OF TSAREVICH ALEXEI NIKOLAYEVICH, *1910–1920*
Silk, lace
*16 x 14 cm / Provenance: 1941, State Museum of Ethnography of the
Peoples of the USSR, previously of Alexander Palace, Tsarskoye Selo /
Inv. no. ERT-6067 / J.P.*

168

CHILD'S UNIFORM OF TSAREVICH ALEXEI NIKOLAYEVICH
AS 2ND LIEUTENANT OF THE 1ST URAL HUNDRED OF THE
UNITED COSSACK REGIMENT OF HIS HIGHNESS'S GUARD,
1910—1920
Russia, St Petersburg
Cloth, silk, wire, goldthread, metal, card, embroidery,
punching, chasing, silver plate
*Length of back of uniform 55 cm; waist 78 cm; trousers 88 cm; epaulettes
13 x 8.2 cm / Provenance: 1941, State Museum of Ethnography of the
Peoples of the USSR, previously of Alexander Palace, Tsarskoye Selo /
Inv. no. ERT-13372, 13374, 13373a,b / S.L*

169

CHILD'S UNIFORM OF TSAREVICH ALEXEI NIKOLAYEVICH
AS 2ND LIEUTENANT OF THE 84TH SHIRVANSKI
REGIMENT OF HIS HIGHNESS'S INFANTRY, *1912—1917*
Russia, St Petersburg
Cloth, silk, wire, copper, braid, spangles, goldthread,
embroidery, punching, silver plate, gilt
*Length of back of uniform 51 cm; epaulettes 13.5 x 8.5 cm; lapels 38.5 x 33.5 cm
/ Provenance: 1973, Pushkin Museum Palaces (Tsarskoye Selo), previously
of Alexander Palace, Tsarskoye Selo / Inv. no. ERT-18200a-d / S.L*

170

CHILD'S UNIFORM OF TSAREVICH ALEXEI NIKOLAYEVICH
AS 2ND LIEUTENANT OF HIS IMPERIAL HIGHNESS'S
REGIMENT OF GEORGIAN GRENADIERS, *1912—1917*
Russia, St Petersburg
Cloth, silk, wire, braid, goldthread, plastic, embroidery,
punching, chasing, silver plate
*Length of back of uniform 57 cm; epaulettes 12 x 8.5 cm / Provenance: 1973,
Pushkin Museum Palaces (Tsarskoye Selo), previously of Alexander Palace,
Tsarskoye Selo / Inv. no. ERT-18198a-c / S.L.*

171

SAILOR'S CAP FROM THE YACHT STANDART, *1900—1920*
Russia, St Petersburg
Wool and silk thread, tin, cloth, leather, ribbon, print
*Height 10 cm / Inscription on St George ribbon in gold: 'Standart'.
Tin cockade on crown / Provenance: 1941, State Museum of Ethnography
of the Peoples of the USSR, previously of Alexander Palace, Tsarskoye
Selo / inv. Nr. ERT-10962 / S.L.*

172

UNIFORM OF TSAR NICHOLAS II AS COLONEL OF THE
GRENADIER REGIMENT OF GUARDS, *1908—1917*
Russia, St Petersburg
Cloth, wool fabric, silk, wire, copper, braid, sequins,
goldthread, embroidery, punching, silver plate, gilt
*Length of back of uniform 65 cm; epaulettes 16 x 6 cm; lapels 48.5 x 40 cm /
Provenance: 1973, Pushkin Museum Palaces (Tsarskoye Selo), previously
of Alexander Palace, Tsarskoye Selo / Inv. no. ERT-18196a-d / S.L.*

173

NAVAL OFFICER'S UNIFORM OF TSAR NICHOLAS II,
1900—1910
Cloth, silk, brocade, wire, copper, braid, sequins, goldthread,
embroidery, punching, silver plate, gilt
*Length of back of uniform 70 cm; epaulettes 16.5 x 12 cm / Provenance: 1973,
Pushkin Museum Palaces (Tsarskoye Selo), previously of Alexander Palace,
Tsarskoye Selo / Inv. no. ERT-18194a-c / S.L.*

174

OFFICER'S UNIFORM OF TSAR NICHOLAS II OF THE
16TH INFANTRY REGIMENT OF TSAR ALEXANDER III,
1890—1917
Cloth, silk, wire, copper, braid, sequins, goldthread, metal
band, embroidery, punching, silver plate, gilt, carving
*Length of back of uniform 64 cm; epaulettes 16.5 x 15 cm; symbol 13 x 18 cm /
Provenance: 1973, Pushkin Museum Palaces (Tsarskoye Selo), previously
of Alexander Palace, Tsarskoye Selo / Inv. no. ERT-18195a-d / S.L.*

175

Olga Nikolayevna Bulbenkova Studio, St Petersburg
GALA COURT DRESS OF
TSARINA ALEXANDRA FYODOROVNA, *c. 1900*
Silk, imitation pearls, imitation fur trimming, silk thread
and wire, embroidery
*Length of bodice 39 cm; dress 103 cm; train 300 cm / Mark on silk ribbon
of bodice corset, printed in gold: 'Mrs Olga Dresses St Petersburg Moyka
no. 8' / Provenance: 1941, State Museum of Ethnography of the Peoples
of the USSR, previously of the wardrobe of Alexandra Fyodorovna in
the Winter Palace / Inv. no. ERT-13146a-c / T.K.*

176

Avgust Lazarevich Brizac Studio, St Petersburg
GREY SILK VISITING DRESS OF
TSARINA ALEXANDRA FYODOROVNA, *1900*
Silk, chiffon, lace, beads, plaited cord
*Length 205 cm / Mark on the satin ribbon of corset, printed in gold:
'A. Brizac St Petersburg' / Provenance: 1941, State Museum of Ethnography
of the Peoples of the USSR, previously of the Winter Palace / Inv. no.
ERT-12858a,b / T.K.*

177

Olga Nikolayevna Bulbenkova Studio, St Petersburg
GALA COURT DRESS OF GRAND DUCHESS
OLGA NIKOLAYEVNA, *c. 1913*
Satin, tulle, imitation flowers, velvet, mother-of-pearl
*Length of bodice 35 cm; dress 138 cm; train 262 cm / Mark on corset ribbon,
printed in gold: 'Mrs Olga. Court trains and dresses. Yekaterinski Canal,
block 68, apartment 4' / Provenance: 1941, State Museum of Ethnography
of the Peoples of the USSR / Inv. no. ERT-13142a-c / T.K.*

178

GALA COURT DRESS, *late 19th century*
Russia, St Petersburg.
Velvet, satin, goldthread
*Length of bodice 37 cm; dress 115 cm; train 259 cm / Provenance: 1941,
State Museum of Ethnography of the Peoples of the USSR / Inv. no.
ERT-13136a-c / T.K.*

179
GALA UNIFORM OF CHAMBERLAIN, *c. 1900*
Russia, St Petersburg
Cloth, goldthread, sequins, gilt
Length of uniform 91 cm; height of hat 17 cm / Provenance: 1941,
State Museum of Ethnography of the Peoples of the USSR / Inv. no.
uniform ERT-10985; hat ERT-11538 / T.K.

180
GALA UNIFORM OF A SENATOR, *c. 1900*
Russia, St Petersburg
Cloth, velvet, goldthread, gilt
Length of back of uniform 98 cm / Provenance: 1941, State Museum
of Ethnography of the Peoples of the USSR, previously of the collection
of Senator E.E. Reitern / Inv. no. ERT-10990 / T.K.

181
MASQUE COSTUME OF COUNT ALEXEI BOBRINSKI, *1903*
Russia, St Petersburg
Silk, gold brocade, gold braid, metal, tailored, saffian,
velvet, goldthread
Length of back of kaftan 121 cm; height of boots 52 cm; length 30 cm /
Provenance: 1941, State Museum of Ethnography of the Peoples of
the USSR, previously of the Bobrinski Family collection / Inv. no.
ERT-13406, 13425a,b / E.M.

182
MASQUE COSTUME OF DUCHESS NATALYA KARLOVA, *1903*
Satin, wire, velvet, silk with goldthread and wire
Length 148 cm / Provenance: 1941, State Museum of Ethnography of the
Peoples of the USSR / Inv. no. ERT-13434 / E.M.

183
Ivan Nikolayevich Kramskoi *(1837–1887)*
FAN, *1886*
Russia, St Petersburg
Wood, silk, gold, mother-of-pearl, carving, oil paint
Length 26,1 cm / Inscription on side: 'I. Kramskoi. 1886' / Provenance:
1941, State Museum of Ethnography of the Peoples of the USSR,
previously of Anichkov Palace / Inv. no. ERT-121696 / J.P.

184
PRIESTLY COSTUME, *late 19th century*
Russia
Velvet, goldthread, silk, cotton, wire, braid, silver,
enamel painting
Length of back phelonion 147 cm; epitrachilion 143 x 27 cm; epigonation
66 x 39 cm / Provenance: 1941, State Museum of Ethnography of the Peoples
of the USSR / Inv. no. ERT-15961, ERT-15963, ERT-15962 / I.K.

185
DIACONAL ROBE, *late 19th century*
Russia, Moscow
Velvet, silk, metal, wire, stamped wire, goldthread, sequins,
freshwater pearls
Length of back 135 cm / Provenance: 1951, State Depot of Valuables
of the Ministry of Finance of the USSR / Inv. no. ERT-16033 / I.K.

186
PURPLE VELVET MITRE WITH GOLD EMBROIDERY,
2nd half 19th century
Russia
Velvet, silk, metal, enamel, wire, sequins, goldthread,
imitation pearls, embroidery
18 x 23 x 23 cm / Provenance: 1941, State Museum of Ethnography of
the Peoples of the USSR / Inv. no. ERT-11532 / I.K.

BOOKS

187
Alexander Nikolayevich Benois *(1870–1960)*
ILLUSTRATED ALPHABET, *1904*
Published in St Petersburg, Izd. Expeditsiia Zagotovleniay
Gosudarstvennykh Bumag (government printing press),
1904, 34 pp., with coloured illustrations
33 x 26 cm / Published in card cover. Ex-libris: 'From the library of
H.I.H. the Heir to the Throne Crown Prince and Grand Duke Alexei
Nikolayevich' / Provenance: 1920s, the Imperial Libraries / Inv. no. 90331 /
O.Z.

188
CORONATION ALBUM. VOLUME I, *1899*
WITH THE APPROVAL OF HIS IMPERIAL HIGHNESS THE
TSAR. PUBLISHED BY THE MINISTRY OF THE IMPERIAL
COURT. COMPILED UNDER THE EDITORSHIP OF
V.S. KRIVENKO. ILLUSTRATED BY NIKOLAI SAMOKISH,
YELENA SAMOKISH-SUDKOVSKAYA AND SERGEI
VASILKOVSKI. INCLUDING ADDITIONAL REPRODUCTIONS
AFTER ORIGINALS BY ALEXANDER BENOIS, VIKTOR
VASNETSOV, KLAVDI LEBEDEV, VLADIMIR MAKOVSKI,
ILYA REPIN, ANDREI RYABUSHKIN AND VALENTIN SEROV.
CONTRIBUTORS TO THE COMPILATION INCLUDE
N. OPRITS, E. BARSOV, G. FRANK, A. ARSHENEVSKI,
V. NOUVEL, F. ZAUNE, K. LINDEN AND S. BELOKUROV.
Two volumes. Published by Izd. Expeditsiia Zagotovleniay
Gosudarstvennykh Bumag (government printing press),
St Petersburg, 1899

Volume 1. XXIII, 428 pp., 66 pages of colour illustrations; many colour
illustrations, miniatures and vignettes in the text; illustrations for titlepage
and first page after watercolour by Nikolai Samokish. / Copy belonged
to Grand Duchess Olga Nikolayevna, eldest daughter of Nicholas II. /
Green leather cover with multicoloured and gold imprint after a drawing
by Nikolai Samokish. An inlaid round metal medal at the top of the cover
shows the profiles of Tsar Nicholas II and Tsarina Alexandra Fyodorovna.
Border inscription: 'Tsar Nicholas II and Tsarina Alexandra Fyodorovna.
Crowned. 1896 in Moscow' / 45 x 35 cm / Provenance: 1920s, the Imperial
Libraries / Inv. no. 367560 / O.Z.

Colophon

Concept & Editing
State Hermitage Museum St Petersburg
Viatcheslav Fedorov
Hermitage Amsterdam
Vincent Boele

Final Editing
Frans van der Avert
Vincent Boele
Heleen van Ketwich Verschuur

Text Editing
Els Brinkman

Translations
Arnoud Bijl *Russian-Dutch*
Donald Gardner *Dutch-English*
Sam Herman *Dutch-English*

Production
Heleen van Ketwich Verschuur

Design
Artgrafica, Amsterdam

Layout
Zeeman en Beemster, Amsterdam

Printing
Waanders Drukkers, Zwolle

Extra photographs Nicholas & Alexandra
© Bettmann / Corbis *(cover, family tree, pages 14 and 42)*

Catalogue from the exhibition
'Nicholas & Alexandra' at the Hermitage
Amsterdam from 18 September 2004
to 13 February 2005, organised by the
State Hermitage Museum in St Petersburg
and the Hermitage Amsterdam.

isbn 0-85331-925-1

Published by
Lund Humphries
Gower House
Croft Road
Aldershot
Hampshire GU11 3HR
United Kingdom

and

Lund Humphries
Suite 420
101 Cherry Street
Burlington
vt 05401-4405
USA

Lund Humphries is part of Ashgate Publishing

WWW.LUNDHUMPHRIES.COM

British Library Cataloguing-in-
Publication Data
A catalogue record for this book is
available from the British Library

Library of Congress Control Number:
2004117537

© 2004 Uitgeverij Waanders B.V., Zwolle
© 2004 Stichting Hermitage aan de Amstel
© 2004 State Hermitage Museum, St
Petersburg

Second edition 2005

State Hermitage Museum
St Petersburg

Director:
 Prof. dr. M.B. Piotrovsky,

Deputy director:
 Prof. dr. G.V. Vilinbakhov,

Deputy Director:
 Dr. V.J. Matveyev

Head of the Department of
Russian Cultural History:
 V. Fedorov

Head of the Department of
Western-European Art:
 Prof. dr. Irina Novoselskaya

Scientific Editors:
 V. Fedorov
 A. Pobedinskaya
 Dr. G. Printseva
 Dr. N. Tarasova

Catalogue Essays:
 Dr. G. Komelova
 A. Pobedinskaya
 Dr. G. Printseva
 Dr. N. Tarasova

Catalogue Annotations:
 Dr. B. Asvarishtch (b.a.)
 N. Avetyan (n.a.)
 Dr. A. Babin (b.a.)
 Prof. dr. N. Briukova (n.b.)
 M. Dobrovolskaya (m.d.)
 L. Yakovleva (l.j.)
 G. Yastrebinski (g.j.)
 Dr. T. Kudryavtseva (t.k.)
 I. Kuznetsova (i.k.)
 Dr. T. Korshunova (t.k.)
 M. Kosareva (m.k.)
 Dr. O. Kostchuk (o.k.)
 S. Letin (s.l.)
 L. Lyakhova (l.l.)
 Dr. T. Malinina (t.m.)
 V. Marishkina (v.m.)
 Dr. Y. Miller (j.m.)
 Dr. G. Mirolyubova (g.m.)
 Dr. E. Moiseyenko (e.m.)
 Prof. dr. I. Ukhanova (i.o.)
 K. Orlova (k.o.)
 Dr. T. Petrova (t.p.)
 J. Plotnikova (j.p.)
 A. Pobedinskaya (a.p.)
 Dr. G. Printseva (g.p.)
 Prof. dr. E. Shtchukina (e.s.)
 A. Solovyov (a.s.)

Catalogue Annotations (*continued*):
 L. Tarasova (l.t.)
 I. Tokareva (i.t.)
 Prof. dr. G. Vilinbakhov (g.v.)
 L. Zavadskaya (l.z.)
 O. Zimina (o.z.)

Photography:
 L. Heifetz
 J. Molodkovets
 T. Nikitina
 S. Pokrovski
 I. Regentova
 E. Shlepkin
 V. Terebenin

Next exhibition:

VENEZIA!
Art of the Eighteenth Century
5 MARCH - 4 SEPTEMBER 2005

Both St Petersburg and Amsterdam have often been called the Venice of the North. The expression is a good departure point for presenting the finest works of St Petersburg's collection of eighteenth-century Venetian art in the Hermitage Amsterdam. In the eighteenth century famous painters such as Canaletto, Guardi, Longhi and Tiepolo ensured that Venice's magnificent artistic tradition would have a suitably grand finale. These artists are generously represented in the collections of the Hermitage in St Petersburg and a selection has been made for the Amsterdam exhibition of paintings, drawings and prints by these and other famous artists. The entire display will be supplemented with splendid examples of the celebrated glass of Venice, that has such an enduring tradition in that city.

VIEW OF THE ISLAND OF
SAN GIORGIO MAGGIORE, *1765 – 1775*
Francesco Guardi,
oil on canvas
State Hermitage Museum, St Petersburg

HERMITAGE AMSTERDAM
NIEUWE HERENGRACHT 14
AMSTERDAM

P.O. BOX 11675
1001 GR AMSTERDAM

TELEPHONE: 020 - 530 87 55
INFORMATIONNR.: 020 - 530 87 51
FAX: 020 - 530 87 50
INFO@HERMITAGE.NL

Information about Lund Humphries:
WWW.LUNDHUMPHRIES.COM

Information about The Hermitage Amsterdam:
WWW.HERMITAGE.NL